IMAGES
of America

DORNEY PARK

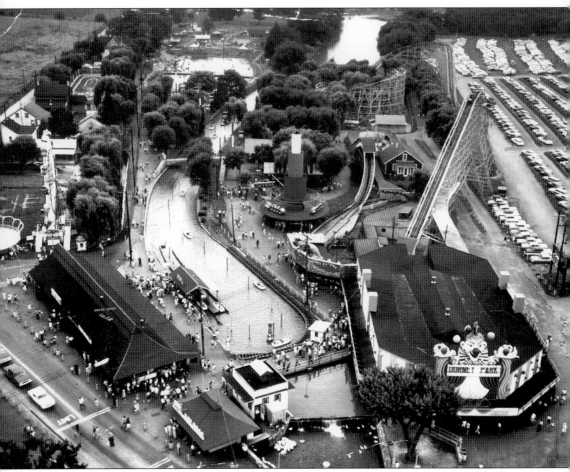

By 1968, Dorney Park had almost evolved into the park that would exist to the end of the Bob Ott regime. Seen here, the route of Cedar Creek is obvious: from top to bottom through the center, starting with the lake at the top, ending with the family of ducks feeding in the pool below the dam at the bottom. The presence of Dorney Park Road at the left and the policeman standing at the stop-and-go turnstile traffic control signal are notable. The old roller coaster, with a car visible atop the first grade, can be seen almost from its beginning to end. The old Mill Chute, by now called Journey to the Center of the Earth, rises next to the rocket ships, now centrally located in the park. It is a busy day at Dorney. The parking lot is filled, with cars overflowing the paved lot onto the adjoining field. Alfundo boldly shows off his famous Dorney Park sign to the lower right.

IMAGES
of America

DORNEY PARK

Wally Ely with Bob Ott

ARCADIA

First printed in 2003.
Reprinted in 2003.

Published by Arcadia Publishing,
an imprint of Tempus Publishing Inc.
2A Cumberland Street
Charleston, SC 29401

Printed in Great Britain.

Library of Congress Catalog Card Number: 2003103444

For all general information, contact Arcadia Publishing:
Telephone 843-853-2070
Fax 843-853-0044
E-mail sales@arcadiapublishing.com

For customer service and orders:
Toll-free 1-888-313-2665

Visit us on the Internet at www.arcadiapublishing.com.

Dedicated to Nick, Mike, Tim, and Richard, my grandsons.
May they become everything I envision for them.

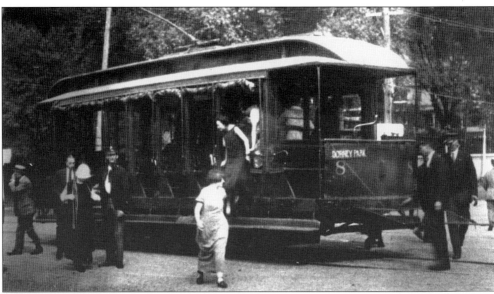

The Dorney Park trolley unloads its passengers at the park entrance at the beginning of the 20th century. With its open sides and four centered wheels, the trolley offered a ride that was breezy and bouncy, but above all the trolley brought traffic to the park. The traction company eventually bought the park and operated it into the 1920s. (Courtesy of the Raymond E. Holland Regional and Industrial History Collection.)

CONTENTS

Preface 6

Introduction 7

Acknowledgments 8

1. In the Beginning 9

2. Castle Garden 25

3. Merry-Go-Rounds 35

4. Roller Coasters 43

5. Swimming Pool and Zoorama 53

6. Trains 65

7. Racetrack 73

8. Everything Else 81

PREFACE

Bob Ott has been an acquaintance of mine for as long as I can remember. Bob and Sally are longtime members of St. John's Lutheran Church in Allentown, as Suzanne and I are. When I was president of the Allentown-Lehigh County Tourist and Convention Bureau in the 1970s, our paths crossed even more frequently. I grew to love and trust Bob. He was an icon in the attractions industry, and I was proud to associate with him for whatever I could learn from the man. More recently, our paths have come together on a regular basis. We both are members of a small, exclusive Saturday morning breakfast group, affectionately calling ourselves the "Geezers." Week after week I hear Bob enliven the conversation with tales of old-time Dorney Park. The little pieces of memorabilia he brings in for show and tell make us all wish we had a key to Bob's basement so we could pore through his collection.

My assignment for *Time-Out Lehigh Valley!* (a cable television program on Lehigh Valley station RCN-4) brought out the best in Bob. It strengthened my resolve to work in more depth with his wealth of history, regarding the amusement park in our town that played a part of the lives of all of us growing up. In that television program filmed during the summer of 2000, I asked Bob about the origin of the little amusement park train at Dorney Park, the Zephyr. Bob knew every nut and bolt in the train. He knew where every part came from, who had designed and built it in the 1930s, and how to operate it. He even took me to the garage that housed a machine shop in a nearby town where the train was built.

When *Time-Out Lehigh Valley!* viewers were asked in late 2002 (during the 15th anniversary of the program) to name their favorite segment of all time, the Bob Ott segment about the Zephyr was the hands-down winner, and Bob's segment was pulled from the archives and aired again on the program.

Bob agreed to talk to me about the park and cooperate in writing this book. That was the first thrill. The rest of the thrills came along, chapter after chapter and picture after picture. Writing the book has been as exciting as riding the roller coaster!

INTRODUCTION

Dorney Park is part of the fabric of Allentown and the Lehigh Valley. In fact, its history encompasses the entire 20th century and more. Through one of those unexplainable quirks of fate, Bob Ott, now an octogenarian still living in Allentown, rose to the presidency of the park and managed its operation for more than 12 years. Bob and his family sold the park in 1985, and the present owner, Cedar Fair LP of Sandusky, Ohio, has developed the old park site into one of America's largest and best-known amusement locations.

Those readers who know Bob Ott might suspect a trick with Bob helping to write this book. He once distributed copies to his friends of an "autobiography" titled *What I Learned in Over 40 Years in the Amusement Park Business*. All the pages were blank. This book is not a trick, and Bob really did learn a lot in his career in the amusement business. He passed along a few Dorney Park souvenir packages to me as we started this book. I had asked to look at his pictures, and by the time I left his house, my car trunk was overflowing with his Dorney Park memorabilia.

By buying this book, readers have paid their admission. Now let's start using those ride tickets. Let's take the Toonerville Trolley to Dorney Park and ride along with Bob Ott and his pictures of the history of Dorney Park. Hold your breathe, fasten your seat belts, and hold on tight.

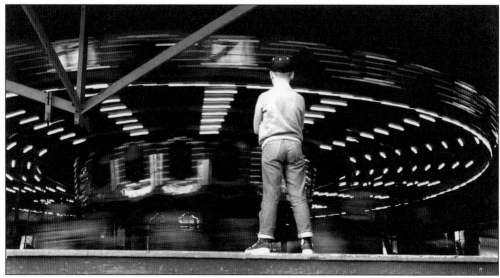

Shown here in 1968, eight-year-old Mark Clauser of Allentown is spellbound by the spinning merry-go-round at Dorney Park. Mark's father, Kenneth Clauser, got his first job as a teenager in 1946 as the ring boy at this same merry-go-round. (Photograph by Ken Clauser.)

Acknowledgments

This book on Dorney Park required the special help of several people. I sincerely thank them for their assistance. Allentown photographer Ken Clauser interrupted many of his afternoons to hear my next request for prints of obscure negatives or slides. As a former press photographer, Ken had a personal darkroom that cranked out what I needed on deadline. The best proofreader I know called to volunteer his services when he learned a book was in the making. Blake Heffner of Hellertown is so particular that he would not let an errant comma get by where it did not belong. The text of the book is the better for it.

David Bausch pored through his collection of photographs and postcards to produce enough images for a book using his material alone. Dave willingly parted with his best to improve my selections for the images you see here. Suzanne Ely gave up our entire dining-room table for the duration of this book-writing project. Finding space to spread out Bob Ott's collection and organize the pictures into pages was harder than it first appeared. As a retired schoolteacher, Suzanne offered invaluable opinions on proofreading, grammar, organization, and spelling. Wouldn't *you* like to have a schoolteacher captive at your word processor when you are working on a text project?

Carol Front, curator of the Raymond E. Holland Regional and Industrial History Collection, also stepped forward and made materials available to the author. Then there are Bob Ott and Sally Ott. They *are* the history of Dorney Park. Bob sat with me through three recorded interview sessions, in addition to dozens of impromptu visits and telephone calls, to confirm facts or get names right. When Bob said early on that I could use anything he had from the park, he was not kidding. Just getting through each box was a challenge. Sally was also consulted repeatedly by Bob for confirmation of long-lost details.

Most of the pictures in this book are courtesy of Bob Ott. Other contributors are credited.

Comments on the book are invited by the author. An e-mail address has been established at DorneyBook@aol.com.

One

IN THE BEGINNING

In 1993, artist and writer Arlene Landers of Bethlehem, Pennsylvania, used these words to introduce her article "Carousel Treasures of Dorney Park" in the *Merry-Go-Roundup* publication of the National Carousel Association:

> On December 31, 1774, Mary Plumstead sold four tracts of land to a gentleman named Daniel Dorney. The land consisted of 279 acres and bordered Cedar Creek in Allentown, Pennsylvania. This transaction began the wonderful and nostalgic history of Dorney Park.
>
> By the year 1870, Daniel's grandson Solomon began using this rich land as an attraction for social gatherings, drawing people from as far away as Philadelphia and New York City. How wonderful the sights must have been, with people arriving in surreys, stagecoaches, and horse and buggy. The attraction at that time was mainly fishing, outdoor games and summer amusements.
>
> As the popularity of "Dorney's Trout Ponds and Summer Resort" increased, a hotel and restaurant were added, and by 1884 the need for mechanical rides emerged, and the name Dorney Park came to be.
>
> In 1901, Jacob Plarr, an immigrant from Alcase Lorraine who was working in Philadelphia, arrived at Dorney Park as a concessionaire, bringing a treasure with him: the park's first merry-go-round. The merry-go-round was installed in the park in the early 1900s and generated much interest, resulting in soaring attendance.

Bob Ott points out, "We always use the date of 1884 when it started as an amusement park, but Solomon Dorney had picnic groves in operation in the 1870s. Solomon came from Cetronia. He was a farmer, and he was quite a well-known man around Cetronia. He was the postmaster and had a general store. Then he started Dorney Park."

Bob continues:

> The Dorney Park Road went right through where the park is today. Solomon Dorney owned the southern part along the stream, Cedar Creek, that went through Dorney Park, around where the road is. Later on, the trolley track went through that same area. Dorney owned the property south of the road. That's where the Mansion House, the restaurant and hotel was added. That's where they had the fish weir, on that side. Later on Dorney acquired a property. It originally was a farmhouse, but then it became a hotel. That whole conglomerate became Dorney's Park. Dorney put a couple of antique rides in.

At the time he developed the fish weir, where he sold fish and served them in the Mansion House. Later on, that hotel became the Penny Arcade. It was a hotel and restaurant. It had a couple of apartments in it. Located up in the center of the park, the building is still there today, but I don't know how long it will remain there. The fish weirs were around the same area, and fresh fish dinners were served in the Mansion House dining room. He also wholesaled fish to other restaurants. For a number of years, Dorney lived in one of the apartments in the Mansion House. He died in the early 1900s; I think it was 1901, a year after he retired.

Dorney put in some rides. The first was two platforms with steps going up to them, some distance apart. They planted a pair of utility poles. A cable was stretched from the top of them, from one post to the other post. The rider went up the steps and was given a single-wheel trolley. You put two hands on it, grabbed hold of this thing, slid across, and ran into the post at the other end, which was well padded because it was an abrupt stop. Allegedly, Solomon used to love to work at this ride and catch the girls bouncing off the pole.

The other ride was the Venetian Swing. Nothing new under the sun when you figure today. It was a double-ended carriage that looked like a boat. You sat in the thing facing each other, and the ride swung back and forth. That was supposed to be your thrill. I guess if you took your girlfriend on there, it was a thrill! I'm sure there were other things, but those were the basic rides that we remember. Then later on, the bigger rides came in.

What happened next changed the whole picture. Solomon's brother O.C. Dorney and some other businessmen developed the Allentown and Reading Traction Company, which provided trolley cars to get people to come out to the park.

Then the traction company bought the park. That's when Solomon stepped out of the picture, around the turn of the century. And that's when Dorney Park really went into amusements. Jacob Plarr got involved, and the first merry-go-round was put in.

Jake ran it one year, and he said, "This is a good deal," and so he bought the merry-go-round, and *he* became the concessionaire at Dorney Park, which was now owned by the traction company. He moved his family up here. They moved into a home in Cetronia. He was a tough old son-of-a-gun; he had a big Prussian beard with the mustache. He was tough. Tough. He never smiled. They tell me Jake would run the merry-go-round, and his wife would sell tickets. And Bob Plarr would be the ring boy. Bob was nine years of age. And nobody got a free ride. Nobody. Jake was a tough operator!

So that was the beginning of the Plarr dynasty. In 1923, Bob Plarr, Jake's son, my father-in-law, and Sally's father, became involved with the park. He had been a ring boy working for his father, and he was involved off and on through the years. In 1923, he became president of Dorney Park. That was the same year the Coaster was put up. That's when it got the name of Dorney Park Coaster Company. Before that it was Dorney Park. Bob Plarr became president, and he began making a lot of changes.

Solomon Dorney brought city people to the country for fun and entertainment. He started Dorney Park in 1884.

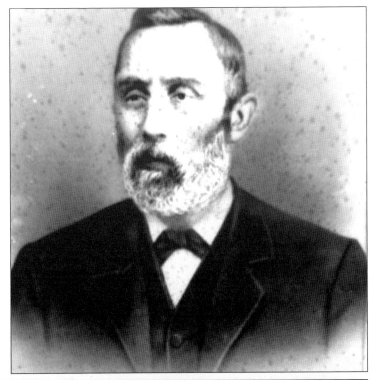

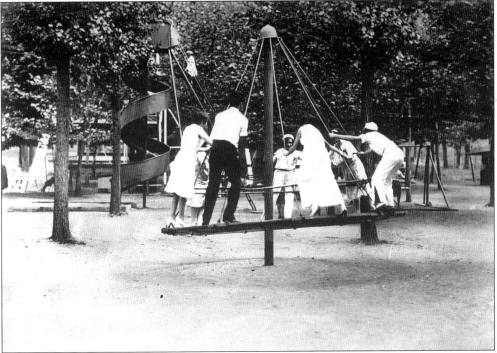

It looks like the kiddie rides at Dorney Park could entertain adults, too. Here this gang, clearly not children, spins around on the ride intended for the young or maybe just the young at heart. Are those sailors in the group?

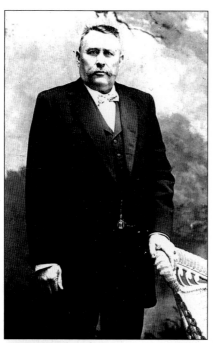

Jacob Plarr took Solomon Dorney's idea for an amusement park and ran with it. He put on his most serious face to pose for this portrait. Plarr brought the first merry-go-round to the property and then oversaw the growth of the amusements. From this start, a little fish hatchery started its trip to becoming one of the nation's leading amusement parks. Plarr started the dynasty that lasted until the sale of the park by Bob and Sally Plarr Ott in 1986.

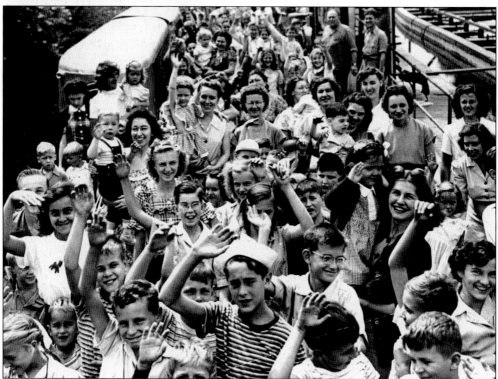

Were you there? It seems like almost everyone in the Lehigh Valley was at Dorney Park for the annual Children's Day celebration. In 1947, this crowd gathered between the Zephyr (on the left) and the Water Skooters (on the right). Two guys we know were there are Bob Plarr and Bob Ott, standing in front of the ticket booth at the top of the photograph.

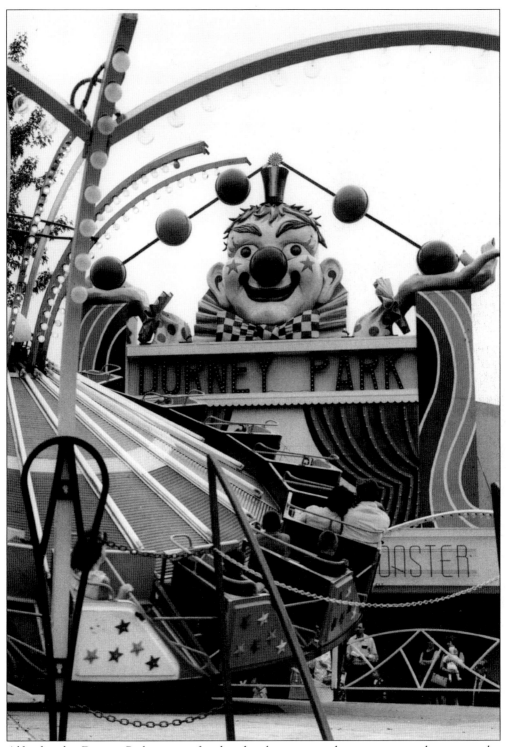

Alfundo, the Dorney Park mascot for decades, looms over the entrance to the spectacular amusement park in Allentown.

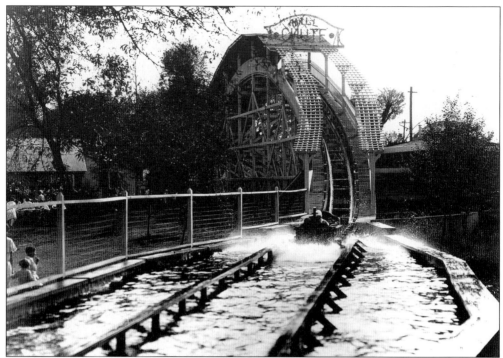

The splash at the bottom of the chute brought us into the daylight and back to reality after each slow, romantic boat ride through the old Mill Chute ride, long before Dorney Park renamed it Journey to the Center of the Earth. Solomon Dorney would have loved it.

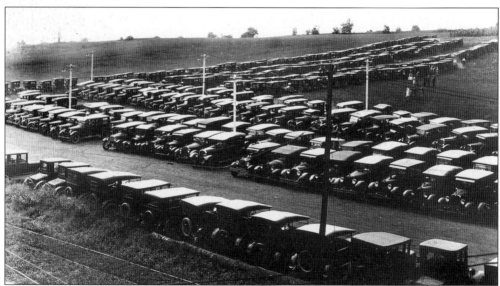

If you do not come by trolley, come by car. A 1929 park brochure read, "Parking facilities at Dorney Park are very exceptional. There is never any question of finding space—over 3,500 cars can be accommodated at one time. And this field is so arranged with entrance and exit that no trouble is experienced in getting in or out. Courteous men are in attendance at all times. They will assist you in getting in and out."

The park was prolific in producing postcard views throughout its history. Here is a postcard about postcards. The little girl is mailing cards back to her friends and relatives. The huge kangaroo delivers the postcards directly to the post office for park-goers. The Kiddie Land roller coaster is shown directly behind the kangaroo.

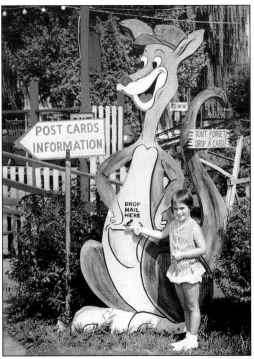

Most Dorney Park lovers remember the Rocket Ship ride at its location near the old roller coaster and Mill Chute building. This picture shows that the ride was originally called the Aerial Swing (or the Airplane Swings) and was located next to the Dorney Park Hotel along the creek. Note that the Dorney Park Road through the property was an unpaved pathway at the time. Bob Ott remembers that the Aerial Swing was dismantled piece by piece by park employees, including Bob, and reassembled at the new site.

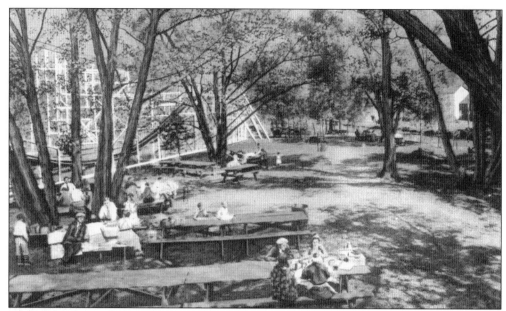

No wonder they called it "the Natural Spot." In the early days, the park was full of trees, grass, and picnic tables. Just a few steps away from all the action of the merry-go-round and the other rides that were springing up, a family could enjoy a picnic lunch in the shade of the grove. An illustrated 1929 park promotional brochure explained, "Some idea of the beautiful shaded groves may be had from the picture above. There are six groves, each with a plentiful supply of benches and tables. Running spring water, a fireplace with plenty of wood already cut, is found in each grove. In case of sudden showers, picnickers may find protection from the rain in one of the five shelter buildings located near each grove. When needed for very large outings, all six groves may be reserved, in which case over 6,000 persons can be easily accommodated."

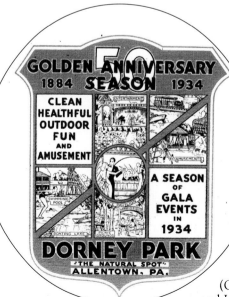

In 1934, Dorney Park celebrated its 50th anniversary. It promised "a season of Gala Events." The shield depicted here, part of a large badge, shows the highlights of the park in those days: the swimming pool, the auditorium, the old train ride, the boating lake, the dance pavilion (still called Al–Dorn in 1934), and the picnic grounds. The badge survives today. (Courtesy of the Raymond E. Holland Regional and Industrial History Collection.)

This musical tower at the entrance to the Dorney Park parking lot rose 90 feet into the air. Colorful neon stripes revolved at night and could be seen from nearby roads and highways. The bells in the carillon system played music that could be heard in the park and for miles around.

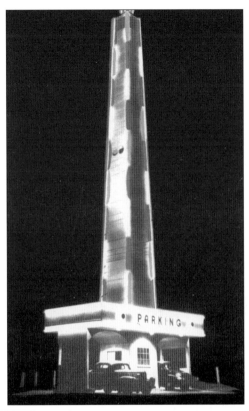

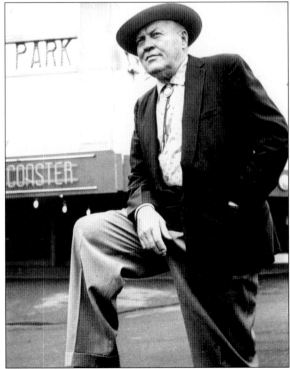

Bob Plarr was born just after Solomon Dorney started Dorney Park, before the beginning of the 20th century, and guided its growth through the decades after his father, Jacob Plarr, got involved with running the park. Dorney retired in 1901. Here Bob Plarr pauses at the park entrance in 1960. (Courtesy of the Raymond E. Holland Regional and Industrial History Collection.)

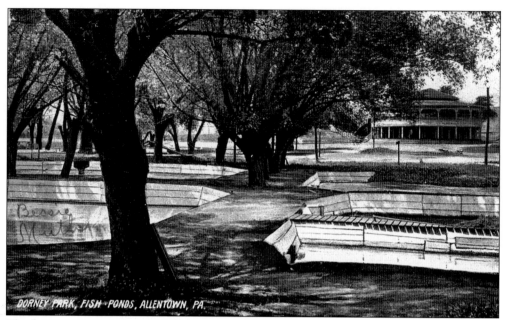

The famous trout ponds, correctly known as fish weirs, started out as rather unattractive open pools. Later landscaping improvements blended the ponds with the environment more successfully, and the ponds became an important part of the attraction. The original casino is visible in the background.

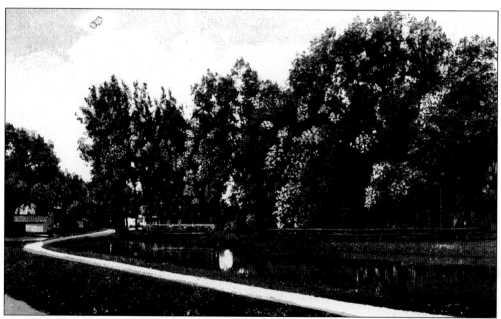

Bob Ott often uses the phrase "Romance flourishes at Dorney." This c. 1900 postcard view of the park is titled "Lovers' Nook, Dorney Park, Allentown, Pa."

18

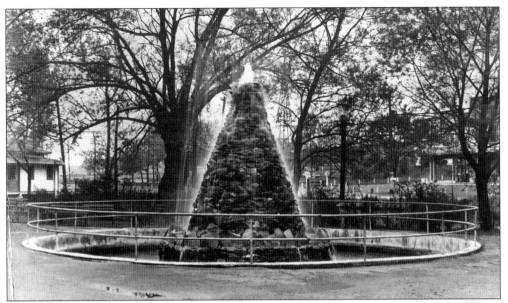

Never to be accused of understatement, Bob Plarr built a spectacular fountain in one of his Dorney Park trout ponds. At night, colored lights ringed the perimeter and beamed through the spray in a 12-minute light show. The hotel is seen on the right. The Aerial Swing is visible in the background.

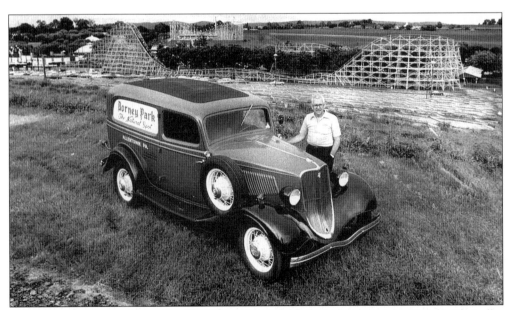

Bob Ott poses next to the park's old 1933 Ford V-8 truck during the summer of 1978. The roller coaster, Flying Dutchman, and other features of the park are visible in the background. The vehicle is preserved in the collection of Allentown historian Ray Holland.

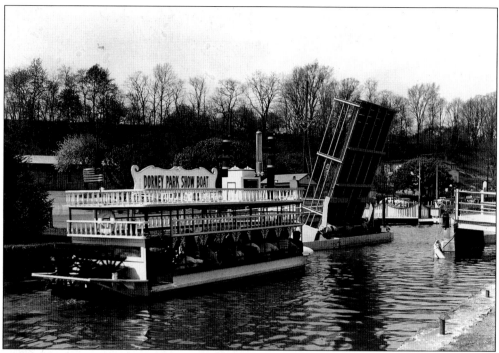

The Dorney Park showboat offered park patrons a cool ride on a small man-made lake. An open drawbridge at the entrance to Castle Garden may be seen along the route of the boat. According to Bob Ott, this is the only operating drawbridge in Pennsylvania.

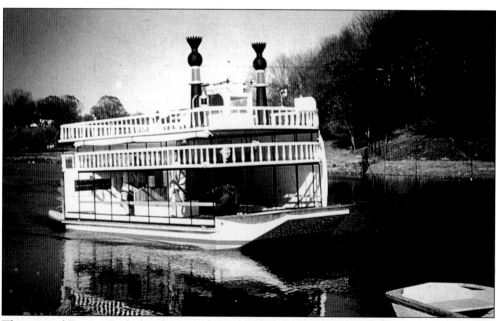

The original Dorney Park showboat predates the later model. Bob Plarr (shown here in the dark suit) peers through the railing as the showboat tours the lake near the park entrance.

A ticket booth from the past was pulled from park storage in 1987 and displayed with a plaque that read, "This booth was used to sell tickets for the original Dorney Park Merry-Go-Round installed in 1904, and operated by Jacob 'Jake' Plarr. Originally it was a pilot house on a Delaware River ferry boat."

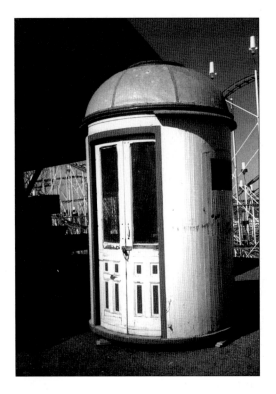

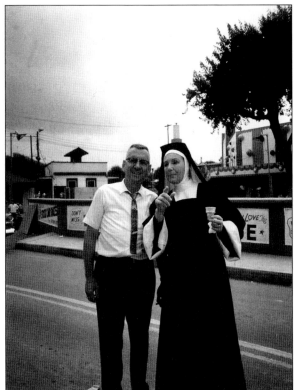

If you want to see Dorney Park in the movies, rent *Where Angels Go, Trouble Follows*. Hollywood actress Binnie Banes enjoys an ice-cream cone during a chat with Bob Ott during the filming in 1968. Rosalind Russell also appeared in the film.

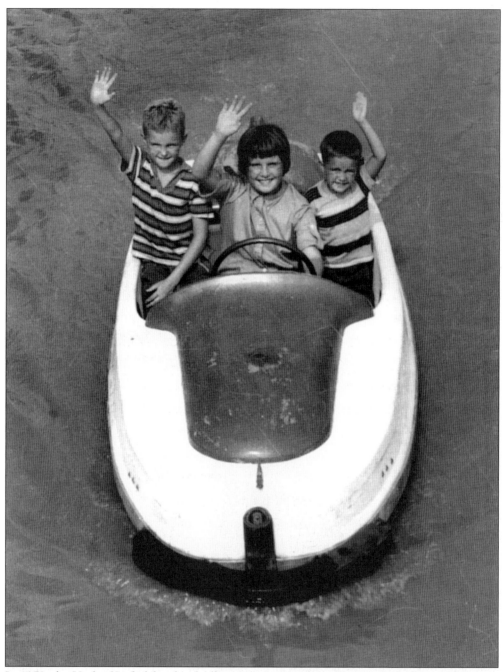

In 1959, the Harley Kunkel family of Allentown spent a day at Dorney Park. "Skooting" along on the Water Skooter are Harley Kunkel Jr., Kimberley Kunkel, and Thomas Kunkel. (Photograph by Ken Clauser.)

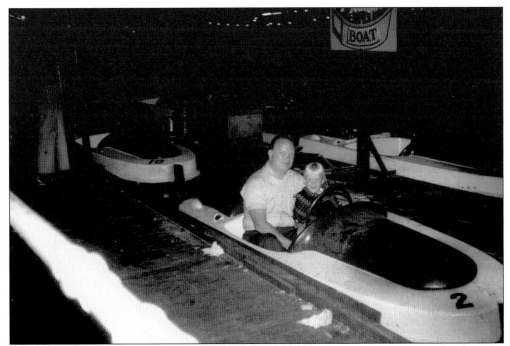

The Water Skooter gave Dorney Park patrons the illusion of driving a boat, but under the water, a track kept the crafts on a course through the pond. The steering wheel did not help much. Here, the author and his daughter Linda Ely take a skooter for a ride in 1969. (Courtesy of Wally Ely.)

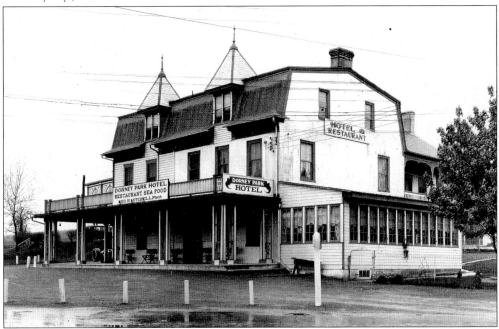

By 1917, the old T.J. Helfrich farmhouse on the park property had become firmly established as the Dorney Park Hotel and Restaurant, one of the main features of a park visit. The structure was torn down in 2002.

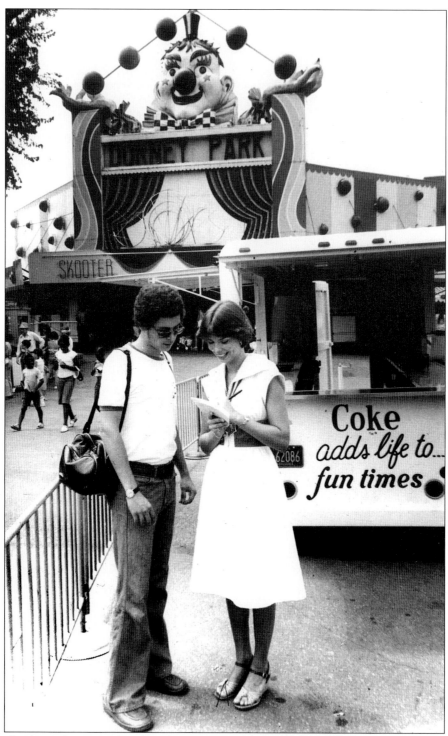

Alfundo, the park mascot for more than 25 years, looms over Miss Teenage America of 1977, Rebecca Reid, as she signs an autograph for 16-year-old Mark Clauser of Allentown. The word "Alfundo" derives from the phrase "Allentown has fun at Dorney." (Photograph by Ken Clauser.)

Two

CASTLE GARDEN

Mention Castle Garden to anyone from the Lehigh Valley, and the memories come forth. For some it was concerts; for others it was dances or proms, Castle Rock, or the popular live radio broadcast series. Then there were private parties, family reunions, and class reunions. Starting in 1923, entertainers of prominence and every nationally famous big band appeared at Dorney Park in the open-air dance pavilion Castle Garden.

A meticulous performer-by-performer log was kept of these performances. It survives today in a small black notebook in Bob Ott's collection. Some pages are typed, and the later entries are in pencil. It was this log that enabled Bob Plarr, Bob Ott, and others to evaluate whether a particular show was worthy of booking again. Shown in this chapter are a few pages of the record book that illustrate how it was done. Readers will recognize many of the performers.

Castle Garden was originally called Al-Dorn, for Allentown and Dorney. It succeeded an older dancing pavilion as an entertainment center at the park. The old building, perched somewhat higher on the hillside, featured a dance area on the main floor. In its declining years in the 1930s, it became a roller-skating rink. It offered two skating sessions every day, and music was provided by an organ and 78-rpm recordings. The building eventually became the Whacky Shack and was destroyed, along with its valuable antique contents, in a fire in 1972.

Al-Dorn remained until a reopening of the facility in 1935 dubbed it Castle Garden. The name was suggested by Allentonian Frederick Kummer, who entered the name in a park contest. At the reopening, the night was filled with comedians, tap dancers, and a roller-skating act, all for one 40¢ admission ticket. Attendance proved that there was a market for a concert and dancing venue in the park, and the new Castle Garden filled the bill nicely.

One of the first mentions of the new facility appeared in the 1925 promotional park brochure, which read:

> Dorney Park has a new Dance Pavilion and floor. It is 90 feet by 160 feet and is one of the finest pavilions in the country. The large pavilion overhangs Cedar Creek, where comfortable rockers will be found for the use of patrons. Dancing is one of the present day modes—one must dance to keep young, and fit to enjoy all the best in life. Careful and strict supervision over a splendid dance floor—that also Dorney Park offers for the 1925 season.

In 1937, the pavilion was enclosed, primarily to prevent the park's nearby deer herd from wandering through the dance floor. Through the 1950s and 1960s, Castle Rock at Castle

Garden featured local disc jockeys from Allentown radio station WAEB, Kerm Gregory and Jay Sands. The series thrived, in the face of stiff competition from other disc jockeys of the day at other sites throughout the Lehigh Valley. Castle Rock's success combined talented and popular hosts, plus the outstanding dance facility in the midst of an amusement park. The name still lingers on, as a present-day radio station promotes an old-timers dance series that still carries the name "Castle Rock," although the facility has been gone for 15 years.

Bob Ott remembers lining up top orchestras, musicians, and recording stars of the day for performances at the weekly dances. Frankie Avalon, Fabian, Louis Armstrong, Jerry Colonna, Vaughn Monroe, Jackie Gleason, and Annette Funicello are among the famous performers with whom he worked.

Allentown High School and many other area high schools made Castle Garden the home of annual junior and senior proms. Many businesses used Castle Garden as the venue for special events for their employees. Banquets, catered by the park staff, would be hosted on the pavilion dance floor, and then other entertainment at the park came along afterward. The famous Hess Brothers department store in Allentown staged regular events at the park, as did the First National Bank of Allentown, Arbrogast and Bastian Meats, and many other businesses.

In 1953, the famous Bluebird racecar of Sir Malcolm Campbell made an appearance in the ballroom. Campbell's record was 300 miles per hour at Daytona Beach. Special supports were added under the floor to accommodate the added weight of the racecar. The glamour of Castle Garden lasted until 1988, when a disastrous fire leveled the hall, several years after the Ott-Plarr dynasty ended.

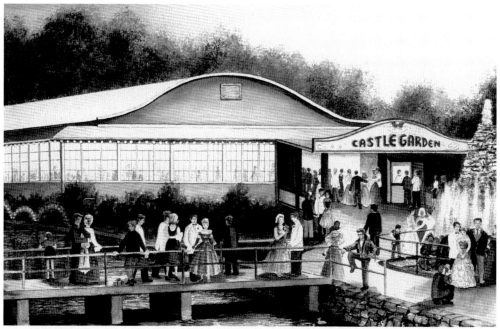

Remember That Special Night is an engaging Dorney Park watercolor by Karoline Schaub-Peeler of Schnecksville. It captures the glamour and excitement of high-school proms and other special events at Castle Garden. Numbered, limited-edition full-color prints are available from the artist. (Courtesy of Karoline Schaub-Peeler.)

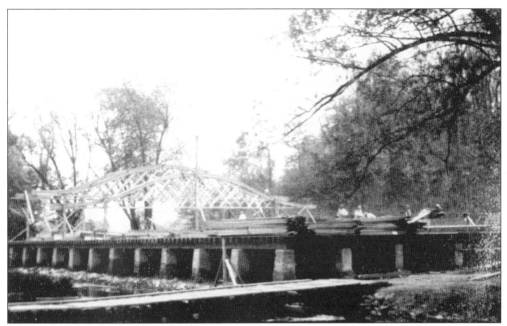

Castle Garden (formerly the Al-Dorn) is shown here under construction in 1925. The latticework was a trademark of the building. (Courtesy of the Raymond E. Holland Regional and Industrial History Collection.)

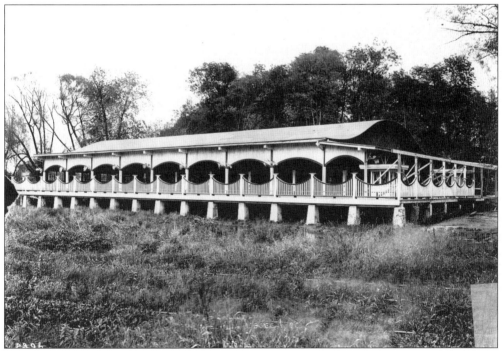

Soon after its completion in 1925, Castle Garden was photographed by the Philadelphia Toboggan Company. In addition to the dance floor, the park was proud of the promenades and porches around the exterior.

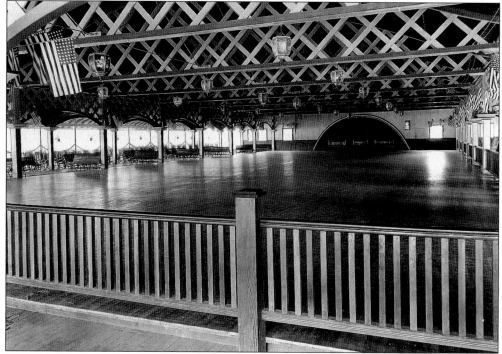

The inside of Castle Garden was as majestic as the outside. There was nothing to match it in its time, and the park kept a busy schedule of dances, concerts, and special events over more than 60 years before it was destroyed in a fire.

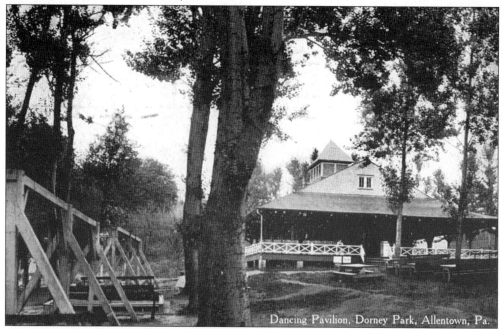

Dancing Pavilion, Dorney Park, Allentown, Pa.

The original dancing pavilion looms over a picnic area, complete with swings for the kids. The pavilion served as a dance hall, until Castle Garden arrived on the scene. Then the pavilion became a roller-skating rink. (Courtesy of David Bausch.)

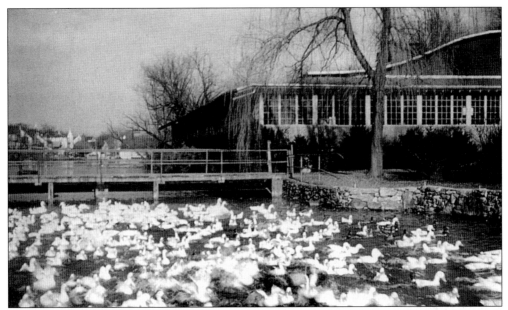

Castle Garden, a dance hall and auditorium, looms over Cedar Creek, populated by hundreds of Peking ducks. From this photograph, it is clear why fresh duck dinners were so common at the Dorney Park Hotel.

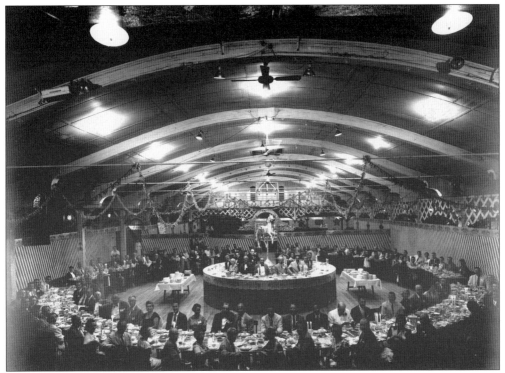

Castle Garden was designed to be multipurpose. Shown here in 1954, the spacious hall is hosting a huge banquet. Visiting members of the International Amusement Park Association dined under this golden carousel pony. (Photograph by Mario Frova, courtesy of Bob Ott.)

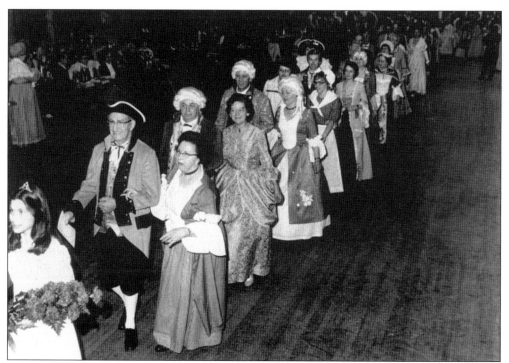

Castle Garden helped celebrate the national bicentennial in 1976. Shown here, Franklin and Myrtle Baer lead the grand parade across the dance floor at Dorney Park. (Courtesy of the Raymond E. Holland Regional and Industrial History Collection.)

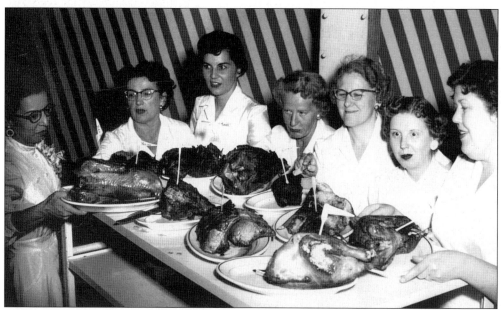

The park catering crew poses with the dinner items before a Castle Garden banquet. Featured is roast duck, taken from the duck population of the ponds and creek at Dorney Park. The Pennsylvania Dutch favorite Seven Sweets and Seven Sours was usually served.

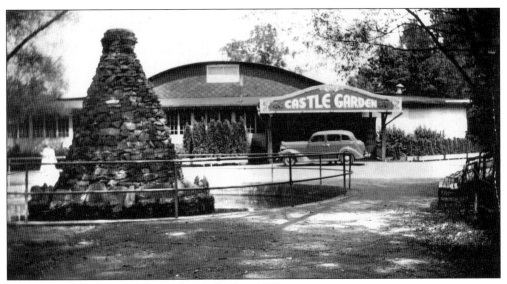

This view shows how Castle Garden looked in 1937.

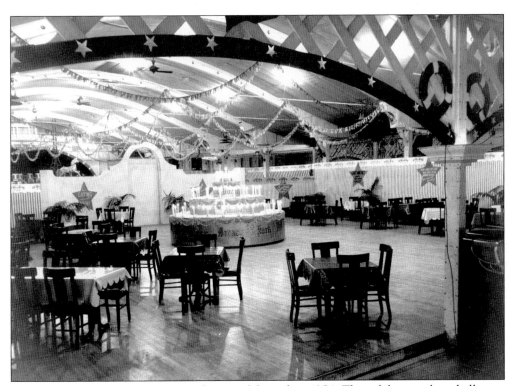

The 70th anniversary of Dorney Park was celebrated in 1954. The celebration lasted all year, but it was highlighted with a banquet in Castle Garden. (Photograph by Mario Frova, courtesy of Bob Ott.)

Date Playing		Name		Price		Mailed	Rec.
4/21	T	Hal Kemp	MC	1000	00	3/29	4/5
4/23	S	none					
4/28	T	Sammy Kaye	MC	750	00	3/29	4/5
4/30	S	Bob Sylvester	MC	200	00	4/16	4/21
5/5	T	L. Armstrong	R-O'K	800	00	4/9	4/14
5/7	S	Howard Woods	MC	200	00	4/16	4/22
5/12	T	B. Goodman	MC	1250	00	3/29	4/5
5/14	S	Dick Messner	MC	250	00	4/16	4/22
5/19	T	Red Norvo	MC	500	00	4/19	4/28
5/21	S	Phil Emerton's Diamonds Paul Wimbish		150	00	4/23	4/28
5/25	W	Kay Kyser	MC	1000	00	4/19	4/28
5/26	T	Woody Leiby	Local	65	00	Here	
5/28	S	Dick Messner	MCA	200	00	5/18/38	
5/30	M	Schadt Bros.	Local	57	50		
6/1	W	Night Riders	Local	65	00		
6/2	T	Bunny Berigan	MCA	400	00	5/18/38	5/25
6/4	S	Ted Black	MCA	200	00	5/23	5/25/3
6/8	W	Night Riders	Local	65	00		
6/9	T	Count Basie	MCA	250	00		6/7/38
6/11	S	Jimmy Littlefield	Ingram	175	00	5/21/38	5/25
6/15	W	Night Riders	Local	65	00		
6/16	T	Paul Tremaine McKnight	Campbell	200	00		
6/18	S	Cotton Pickers Geo. Pugh		150	00	5/21/38	6/1
6/22	W	Night Riders	Local				
6/23	T	Casa Loma	R O'K	700	00	4/19	4/21
6/25	S	Bert Black	MCA	200	00	6/16/38	6/2
6/29	W	Night Riders	Local	50%			
6/30	T	Sammy Kaye	MCA	500	00	6/21/38	6/23

The old ledger pages from 1938 show that a meticulous record of each performance at Castle Garden was kept. A profit of as much as $346 was made on a winning performer, and the park lost up to $328 when attendance was off. The performers included Louis Armstrong, Sammy

32

Adm. Cost	Admissions Paid	Comp.	Gross Less Tax	Cost	P - L
1.00-.10	774	61	773 71	1000 00	− 226 29
00-.10	1096	67	1096 80	750 00	346 80
0	649	---	259 35	200 00	59 35
00-.10	282	82	283 20	800 00	− 516 80
0	660		263 85	200 00	63 85
00-.10	1327	110	1326 99	1250 00	76 99
0	370	4	148 40	250 00	− 101 60
-85	271	60	209 52	400 00	− 190 48
0	916	6	366 95	171 00	195 95
	674	70	672 00	1000 00	− 328 00
5	223		55 70	65 00	+ 9 30
0	852	13	340 75	200 00	140 75
0	486	3	194 30	57 50	136 80
.25	235	1	58 75	65 00 (Pd. 142.15)	+ 6 25
8-7) .35	383	61	156 00	400 00	13 85
0	827	3	331 00	200 00	131 00
5	328		82 00	65 00	17 00
-5	342	30	170 91	250 00	− 79 09
	747	4	322 90	175 00	147 90
	326		81 45	65 00	16 45
-5	165	30	82 50	200 00	− 117 50
	757	10	302 95	150 00	152 95
	237	73 Whitehall	58 99	65 00	+ 6 01
00-.10	722	92	722 71	700 00	22 71
0	719		287 90	200 00	87 90
5	300	3	75 00	65 00	10 00
00-.10	319	78	318 90	500 00	− 181 10

Kaye, Bunny Berrigan, and Benny Goodman. More than 1,000 admissions were logged for Sammy Kaye and Benny Goodman performances. Bob Ott's black book covers each year until 1948.

A bigger-than-life diamond dominated the horizon along Dorney Park Road in 1965, when the park celebrated its 75th year, the Diamond Jubilee. Shown here during the festivities are, from left to right, Steve Plarr, Bob Plarr, and Bob Ott.

Three
MERRY-GO-ROUNDS

Describing the coming of rides at Solomon Dorney's picnic and park site, Bob Ott observed:

What happened in 1901 changed the whole picture. Solomon's brother O.C. Dorney and some other businessmen developed the Allentown and Reading Traction Company, which provided trolley cars to get people to come out to the park. Then the traction company bought the park. And that's when Solomon stepped out of the picture. This is around the turn of the century. And that's when Dorney Park really went into amusements. Jacob Plarr got involved, and the first merry-go-round was put in. The trolleys made the explosive growth of the park possible.

I didn't know Jake too well. I knew him, I could say, because of the circumstances, but then I went away to school, and I went to sea. While I was away, he died. Jacob Plarr was the guy who developed the bigger amusement park rides in the park, the merry-go-round and later on the Whip.

The first Dentzel, a landmark ride, was brought to Dorney Park in 1901 by Jacob Plarr. He ran it as a concession until 1923, when it was put in storage, as new ownership took over the park. The magnitude of the beauty of the ride almost let the rider overlook the menagerie of animals traveling the spinning platform. There were 40 in all. Bob Ott lists 31 horses, 1 dog, 1 tiger, 2 lions, 3 giraffes, 1 hippopotamus, 1 camel, and 4 chariots. A Wurlitzer organ provided the music.

In 1954, the ride reappeared, painted gold in commemoration of Bob Plarr's 50th anniversary of running the park and the 70th anniversary of the park itself. Again, in 1969, this merry-go-round resurfaced as part of the park's 85th-anniversary celebration. Finally, the nation's bicentennial in 1976 saw the ride operating again, this time adorned in red, white, and blue. Unbelievably, after Ott sold the park, the carousel was taken apart by new owner Harris Weinstein and sold piece by piece to collectors.

In 1965, Bob Ott and Bob Plarr visited Coney Island, New York, to look up some rides they had in mind to buy for the park. Unexpectedly, a unique carousel was shown to them, and although it was not what they were looking for, they bought the ride for Dorney. The Chanticleer merry-go-round featured roosters and an ostrich for the riders, instead of the customary one-rider carousel horses. Most notable of all was that after the ride had been built c. 1900 in England, as it was being transported to America, the ship that held it sank in the North Sea. After several years, the ship and its contents were salvaged. The ride was restored

and began operating in 1913 in Steeplechase Park at Coney Island, where the Dorney shoppers found it. By 1966, the ride had proven to be less than popular at Dorney and expensive to maintain. It was put in storage. In 1973, it was lost to a fire in the storage building.

Humbly dubbed "Le Grande Carrousel," the Dorney Park merry-go-round most of us grew up with was created by the Philadelphia Toboggan Company of nearby Lansdale in 1916. The carousel was purchased by Dorney from another amusement park in Delaware in 1932. The ride was originally located in an open-sided building, but at Dorney it was enclosed in a glass structure. All the beauty and majesty of this carousel, both its sight and sounds, created memories for children of all ages visiting the park. A fire in 1983 destroyed the ride, just as an anniversary year of celebration for the park came around. The original Dentzel merry-go-round was pulled from storage and was featured in the festivities.

A merry-go-round with an interesting legend operates in the park now. Also a Dentzel, it was built in 1921. According to park promotional material, "Legend states that while the ride operated at Cedar Point, the ghost of a woman would take nightly rides on this carousel after the park closed, on one particular military horse designed by Daniel Muller. This horse remained at Cedar Point after the carousel was moved and is not part of the Antique Carousel at Dorney Park and Wild Water Kingdom." Dorney has the ride, but the haunted horse and the ghost apparently did not come with it.

Shown here is the lead horse on Le Grande Carrousel at Dorney Park. This colorful character marched round and round, right behind the chariot, leading the parade under the lights. The Wurlitzer organ blared in the background.

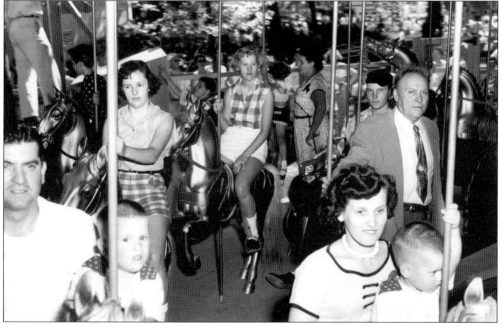

When the original Dentzel merry-go-round was reactivated for an anniversary in 1954, it was painted gold. Bob Plarr, on the right, checked out the merry-go-round along with the many other riders.

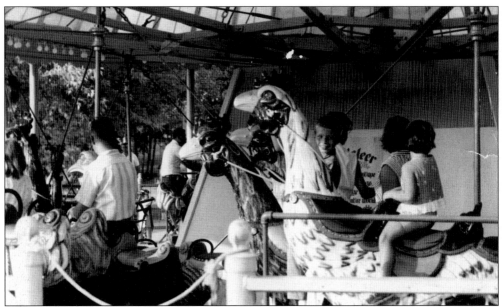

The Chanticleer was popular with enthusiasts for the exclusive ride it offered, but ticket sales never met projections, and its maintenance costs were higher than expected. Park officials admitted that kids liked to ride horses but not roosters. The roosters were stored away until destroyed in a fire.

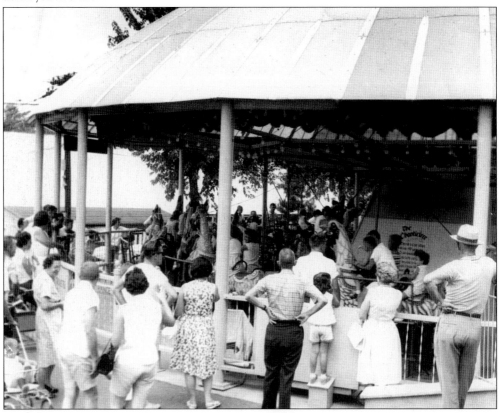

The author and his family spent this day in 1967 at Dorney Park. On this carousel ride are Suzanne, Scott, Linda, and David Ely. (Photograph by Wally Ely.)

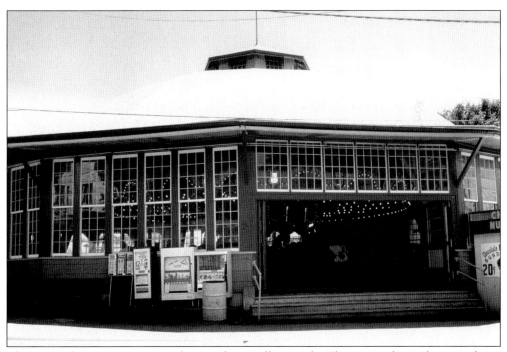

The carousel was an imposing sight outside as well as inside. This image shows the view that a Dorney Park patron of the past would have seen upon approaching the merry-go-round. By this time, the music and the action would be drawing patrons inside. (Courtesy of the Raymond E. Holland Regional and Industrial History Collection.)

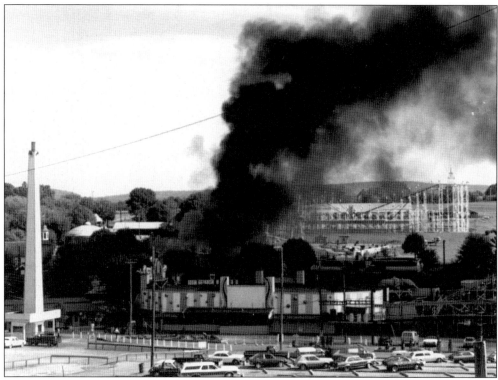

The old wooden buildings were no match for the high winds and raging flames that devoured the merry-go-round and several other buildings a few days after the park closed for the season in 1983.

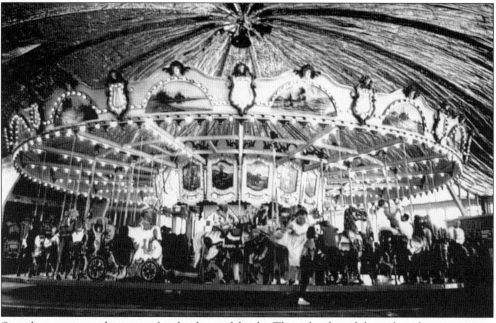

Size alone commands respect for this beautiful ride. The splendor of the color, the movement, and the music make it unforgettable. (Courtesy of David Bausch.)

This view shows the original building that served as an entrance and housed the Scenic Railway.

A seat from the old Toonerville Trolley that brought city folks to the Dorney Park after the turn of the century is all that remains of that era. The seat was saved and donated by Bob Ott to the Lehigh County Historical Society, where it is now on display.

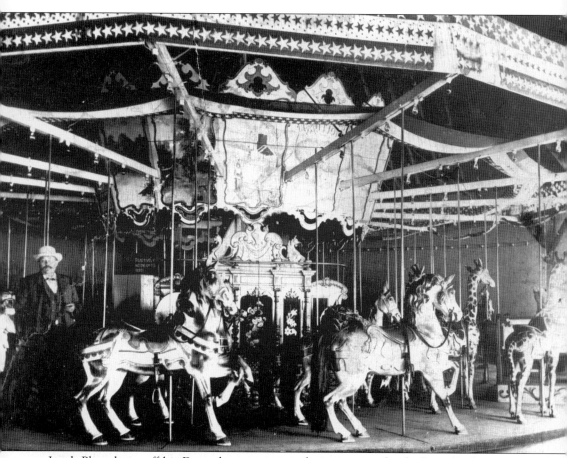

Jacob Plarr shows off his Dentzel merry-go-round many years after he brought the attraction from Philadelphia to Allentown and started the movement that turned the park into the Dorney Park we know today.

Four

ROLLER COASTERS

First came the Scenic Railway, an early indicator of the rides and amusements that were to make Dorney Park a major community attraction. The Scenic Railway ran through the park property, somewhat along the route of the later roller coaster, but without the roller coaster's speed and the thrills.

By 1923, Bob Plarr had worked out a deal with the Philadelphia Toboggan Company to construct a new ride. It was formally called the Roller Coaster until it became the Thunderhawk in the 1990s, an attempt to keep up with the newer and faster attractions that were coming on board year after year. The roller coaster was all-wooden construction. It started life as an out-and-back ride. It was fast, running at a reported 63 miles per hour at a height of 72 feet. By 1930, a major reconfiguration had changed the ride into a figure eight, lengthened the trip, and increased the height to 80 feet. The twisting and dropping of the new design preserved the coaster into the 21st century.

The coaster was continually updated for safety and speed. Comfort and enjoyment of the passengers was of primary importance. In the ride-ticket days, a satisfied rider might just fork over another handful of ride tickets to stay on again if he enjoyed the experience. Bob Ott says that he has personally walked and inspected every inch of the ride, and he has replaced aging tracks and structural parts many times over.

There were two trains of cars. While one set was moving out, another was being loaded at the platform. Operators controlled departures to keep a distance between the rides. Every now and then, someone would try to give the coaster a new name. Nothing stuck. Until relatively recently, it remained simply the Coaster. At one time, even the name of the company was changed to Dorney Park Coaster Company. By the 1990s, modern marketing requirements forced a name change of the old coaster to Thunderhawk, and the old coaster is still running with this new name.

Counting the Laser and the coaster, two hands are needed to tick off on fingers all of the thrill rides the park has seen. Consider Wild Mouse, the Flying Dutchman, Steel Force, Hercules, Talon, Meteor, and Dominator. The little Scenic Railway pales by comparison. From the beginning, bigger and faster rides were needed to beat the competition and keep the customers coming back for more.

The Dorney Park coasters became embroiled in a media battle in 1989, when Six Flags over Texas announced its new coaster and claimed that it was the "world's tallest." Six Flags did not count on Dorney standing up for its Hercules, which at 157 feet topped the run of 137 feet at

Six Flags. Dorney's ride had a hillside start, which enabled it to have a more lengthened drop. In 1990, Dorney's federal lawsuit against Six Flags ended with a settlement in which each claim was accepted by the other park. Today, neither drop is in the running, as higher coasters continue to appear, starting with the one at Fiesta Texas in 1992. Even Dorney's own Steel Force went on to top the list when it opened with a drop of 205 feet. The end is not yet in sight. In this century, Cedar Fair management continues to research the newest and fastest rides for potential upgrades to more thrilling adventures in the park.

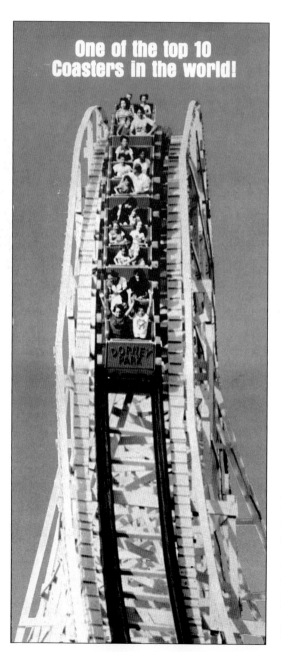

One of the top 10 Coasters in the world!

Starting with the new coaster in 1923, the Dorney Park coasters were always among the tops in the nation—and still are today. The coaster is headed down that first vertical drop to the delight of the trainload of thrill seekers. By 2003, the park fact sheet on rides listed eight roller coasters. Coasters are the Talon, Wild Mouse, Steel Force, Hercules, Laser, and Thunderhawk, plus kiddie coasters Woodstock Express and Little Laser.

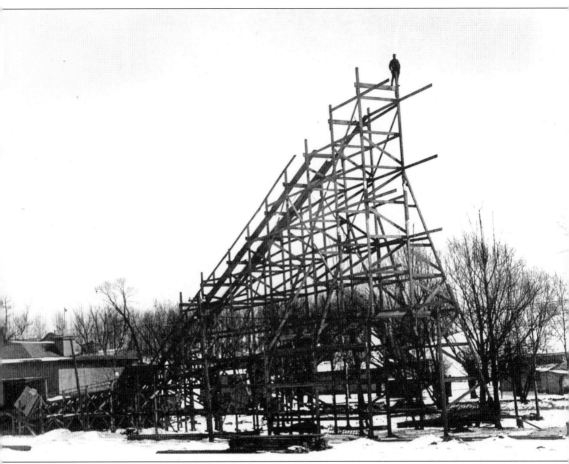

Bob Plarr poses atop the original Dorney Park coaster during construction in 1923. Plarr must have done a good job with his project. It is still running under the name Thunderhawk 80 years later.

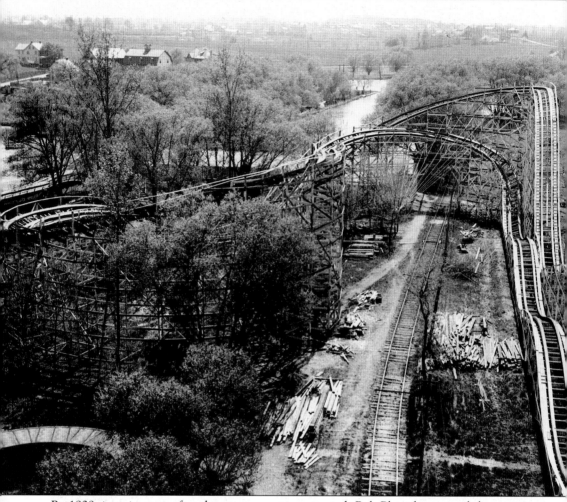

By 1929, just six years after the coaster was constructed, Bob Plarr determined that a newer, faster, more curvy route was in order. The old route was basically out-and-back. The new route wound into the picnic area and crossed the trolley tracks twice. In fact, the trolleys came in handy during construction. Bob Ott says that the trolleys were used to pull heavy wooden sections of the new track into place.

It is okay to wave, but do not stand up! This group was celebrating a Children's Day outing at the park. These special events featured periods throughout the day when the rides were free, and kids swarmed the park to take advantage of the offer. Strips of free tickets were distributed with the local morning newspaper. Bob Ott says the kids showed up with hands full of the freebies.

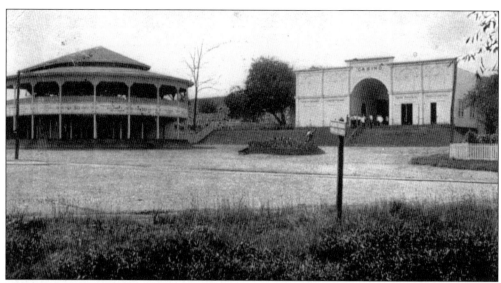

In 1906, the Dorney Park entrance was made up of the Scenic Railroad building and the Casino.

By the time of this picture in 1950, the Scenic Railway had given way to the roller coaster (in 1923), and the new building to house it. The Casino was gone entirely, thanks to a roof collapse during a snowstorm in 1936. The picture also shows the entrance to the parking lot and the musical carillon tower.

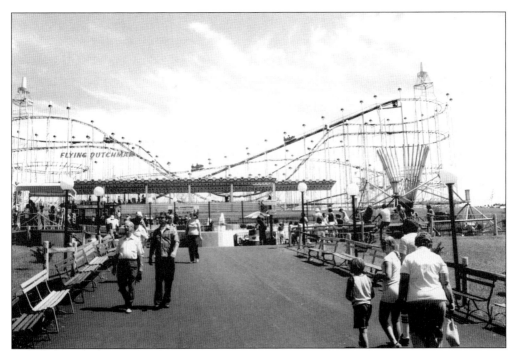

The Flying Dutchman changed the skyline of Dorney Park c. 1972. It was located on the hillside of the southern portion of the park property, which was newly obtained in a land swap with Lehigh County.

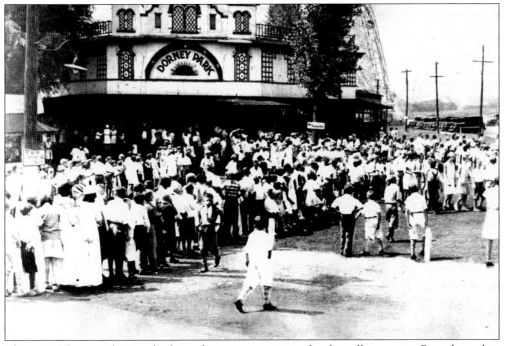

This c. 1925 image depicts the line of passengers waiting for the roller coaster. Boys dressed in knickers and high socks, as well as white shirts, to visit Dorney then. Can you follow the devious route of the line as it snakes around outside the coaster building?

There was not all that much on the property by 1926. This picture tells a few tales. The trolley line that follows the creek crosses Dorney Park Road and enters the park. There are two tracks, one for loading, while another trolley car is arriving or leaving on the second track. An early version of the Airplane Swings ride looms at the left. This ride was eventually relocated in the center of activities as the park grew up to the west of this view. The farmhouse-inn-hotel-tavern is near the center of the picture. Other buildings visible are the Casino on the left and the roller coaster on the right. Castle Garden, still named Al-Dorn, had made an appearance by this time and is visible across the road from the hotel. Cedar Creek followed a slightly different route than we know today and seems here to run under Castle Garden. Bob Ott says it just *looks* that way. The creek never ran under the dance facility. (Photograph by Allentown Photographic Studio, courtesy of Bob Ott.)

DORNEY PARK, ALLENTOWN, PA.
OPENING DAY
MAY 25

ALLENTOWN BAND

OPENING DAY
SUNDAY AFTERNOONS
AND HOLIDAYS

DECORATION DAY
THURSDAY EVENINGS

DANCING

TUESDAY
THURSDAY
SATURDAY

The announcement of the opening day in 1907 was pretty basic. Highlighted was the Allentown Band concert. The band held regular performances at the park each year.

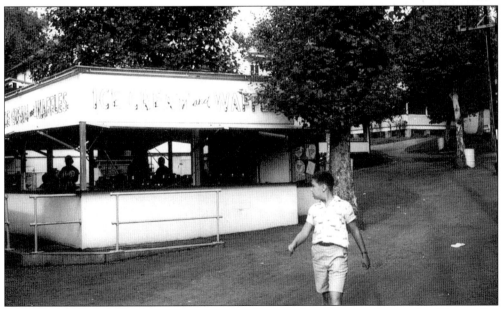

It was strictly local, but the ice-cream and waffles stand was extremely popular. The waffles were freshly made on the site in a large bank of waffle grills by chefs who took pride in the results. The ice cream was made at the park as well. It was cut into blocks with a custom cutter created for that purpose. The combination of ice cream and waffles was irresistible.

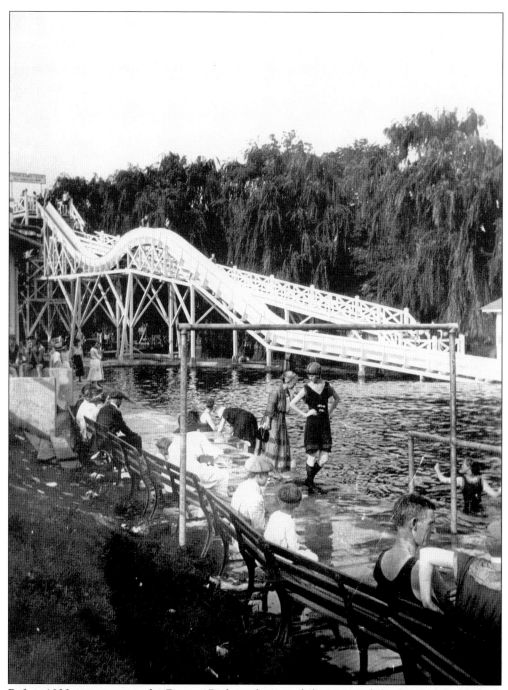

Before 1920, swimmers at the Dorney Park pool enjoyed the water while almost fully clothed. Men wore black one-piece suits, long black socks, and shirts. Caps were worn by swimmers of both sexes and all ages. The complex flume slide featured at Dorney, called the Sellner Slide, was years ahead of its time.

Five

SWIMMING POOL
AND ZOORAMA

If there had been a *Guinness Book of World Records* at the beginning of the 20th century, Dorney Park and its swimming pool would have been in it. The park boasted in 1900 that its pool was the "largest artificial swimming pool in the world." "Biggest and finest in the land" and "as finely equipped as any outdoor pool in America" were the words used in advertising the pool. Swimming and Dorney Park are just about synonymous. From the earliest days of recreation at the park site, visitors enjoyed the water.

Early in the 20th century, Jacob Plarr created a swimming pool near the western end of the property by diverting part of the creek that flows through the property. This spring-fed stream made for very cold water at the swimming hole. Eventually, the pool was expanded, but the signature sandy beach and sandy bottom were retained through the 100-year history of the swimming area at the park. At some time in the distant past, the pool represented a unique type of segregation. Men and women were not allowed to swim together. The swimming area was clearly divided to keep the sexes apart, and there were two separate bathhouses as well.

From the beginning, professionals were hired to manage the pool. In fact, the pool was run as a concession for most of its life. The pool was so successful that, in spite of competition from municipal pools in surrounding communities, it was the highest-grossing activity at the park for most of its tenure. We do not have records of all of the people who managed the pool during its lifetime, but the several we do know about are notable. The first name connected with the pool was Capt. L.D. Blondell. On June 1, 1900, he wrote to the public from New York City:

> I take pleasure to announce in this connection that I have completed arrangements with the management of Dorney's Park to take charge (for the entire season) of their new bathing and swimming beach located on the line of the Allentown & Kutztown Traction Co., four miles west of the city of Allentown, Pa.
>
> I have secured the services of the principal members of the famous Blondell "Monumental Life Guards" of Point Breeze, Md., Professor S.W. Kimball, Instructor Seventh Regiment, New York

National Guards' Gymnasium; Mr. John Harter, Coney Island, and Mr. Ed. Dayle of Ocean View (Hampton Roads), Va.

My aquatic exhibitions during the entire season here will be the same as given by me at all the principal American and European watering places.

In addition to the regular exhibitions, a swimming school for all those who desire to learn the "art of swimming" will be conducted by the most expert and experienced instructors and water gymnasium directors in America, which at once commends itself to the citizens of Allentown and vicinity since this is the only inland watering place in Eastern Pennsylvania where exhibitions and instructions of this nature are afforded to the public.

Guaranteeing highly instructive and entertaining aquatic exhibitions, as well as strictly first-class service in every respect to every patron of the swimming and bathing beach, I am, Swimmingly yours, Capt. L.D. Blondell, Champion Long-Distance Ocean Swimmer of the World.

There is no record of how Blondell succeeded. By c. 1933, however, Thomas A. Jacks was in charge of the pool. Allentonians knew Jacks as "Tommy Jacks," the vice principal at Harrison-Morton Junior High School. Jacks worked for the Allentown School District most of the year and managed the pool during the summer. Jacks became school principal during the mid-1940s. He and his wife, Hannah Jacks, like most others who had the responsibility of managing the pool, lived in the apartment over the bathhouse. Jacks was a good candidate for the job of managing the pool. He followed in the footsteps of the previous manager, David H. Jacks, his father.

By the 1940s, the pool was under the management of the popular swim instructor from Allentown High School, David "Davey" Hackett. The Hacketts managed the operation and lived in the bathhouse apartment. Hackett had a reputation for producing winning swim teams at the school, and Dorney Park gave his students the perfect place to work out and practice during the summer months. The team members could be seen serving as lifeguards almost any summer day. In 1962, the park announced that after 61 years of operation, the pool would be closed. The costs of remodeling the pool were considered exorbitant, and closing it was the only option.

A new attraction evolved a year later at the pool site, Zoorama. Robert Deitch of Fair Lawn, New Jersey, brought his collection of animals to Dorney. Deitch used the former bathhouse as the main building to house his array of animals. Other exhibit animals lived in the old swimming pool. A boat ride called the Whale Boats also traversed the water. Those who never saw Zoorama will find it hard to believe that the old swimming pool area housed monkeys, turtles, jungle birds, rabbits, a kangaroo, leopards, bear cubs, chimpanzees, a hippopotamus, a giraffe, lions, sea lions, and other exotic animals.

Zoorama made unwelcome headlines one day in August 1964, when a fire started in the apartment in the building and quickly spread to the lower level where the animals were housed. Heroic efforts by park employees, who battered down walls and hauled cages full of frightened animals to safety, resulted in the fire causing the death of only a few of the many animals.

During the furor over the fire, the kangaroo escaped and bounded along the stream, enjoying some brief moments of freedom. The hippopotamus lounged in the pool, watching the action. After the fire was extinguished, three alligators, given up for dead, surfaced from their refuge underwater in their indoor pool, inside the building that had largely been destroyed by the flames. Deitch claimed Zoorama would reopen, and by the next season, it was back.

This 1900 rendering shows Capt. L.D. Blondell, Dorney Park's first swimming pool manager. No one knows what Blondell was a "captain" of, but he was proud to announce his new position as manager. He promised to bring along the "Monumental Blondell Life Guards." He called himself the "Champion Long Distance Swimmer of the World."

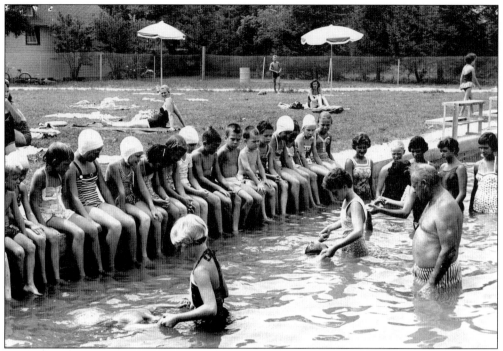

During a warm summer morning in the 1950s, pool manager Davey Hackett supervises "floating instruction" during swimming lessons for a class at the pool. The swimmers, mostly underwater, are "Tex" School, Scott Wood, and Linda Jane Wetner. The instructors are Diana Lichtenwalner, Sharon Diehl, and Eleanor Haines.

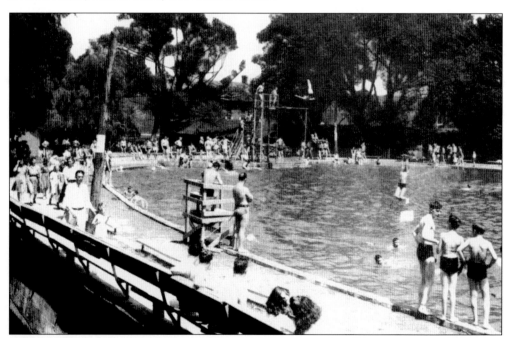

By the 1950s, a swim at Dorney made the park outing complete. The water was cold because the pool was spring-fed from adjacent Cedar Creek.

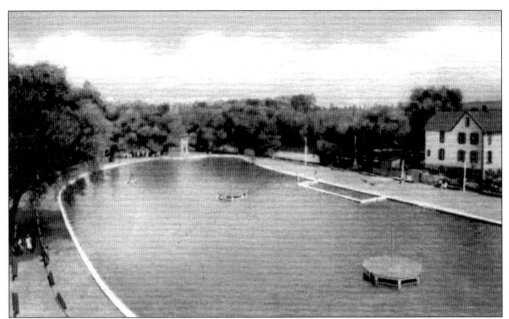

Usually jammed with swimmers, the Dorney Park swimming pool is almost empty. Maybe it is too cool? The sandy beach was a feature of the pool long before Wild Water Kingdom was invented. The publisher of the postcard depicted here gives the park its nickname, "the Natural Spot." The postcard points out the sandy beach around the pool and notes that "pure, fresh everflowing water, handsome modern bathhouse, and modern equipment are here for the amusement of its patrons."

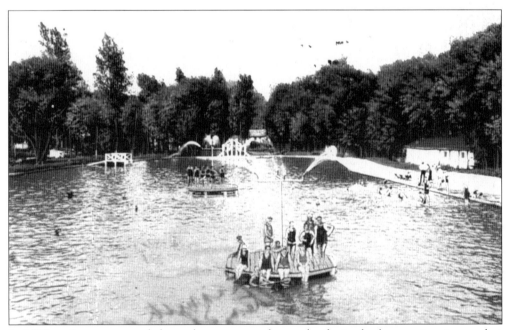

In 1927, swimmers sunned themselves on one of several rafts in the huge swimming pool at Dorney Park.

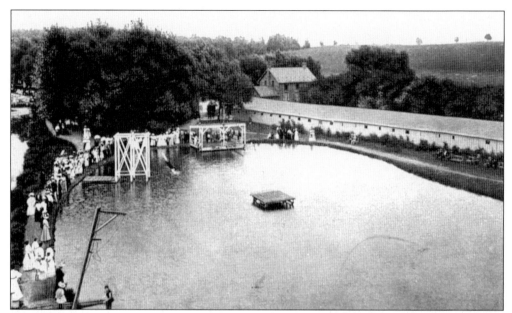

A major attraction at Dorney Park was the swimming pool. From early in the 20th century, the pool brought city folk out to the country for a cool dip on a hot day. The long shed visible in this print might be mistaken for a bathhouse next to the pool, but it is not. The shed was a stable to house visiting horses and wagons while their owners patronized the pool and the park. The photograph was taken *c.* 1910. (Courtesy of David Bausch.)

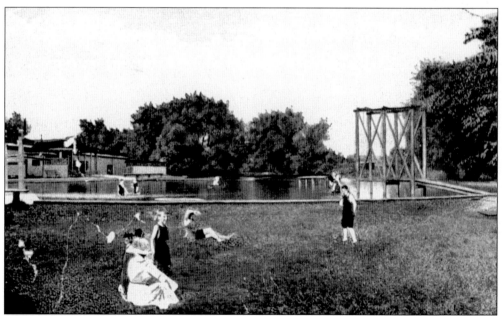

Bathers frolic on the grass near the Dorney Park swimming pool. Municipal pools were not common in this era, and the Dorney pool represented an important destination on hot summer days.

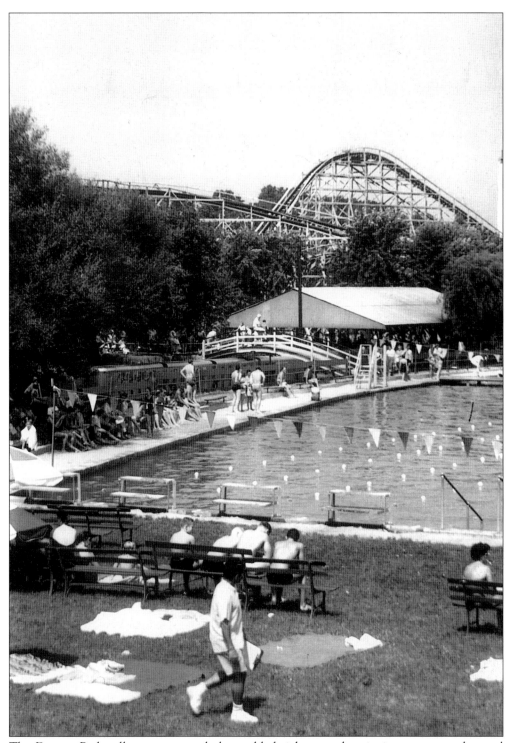

The Dorney Park roller coaster regularly rumbled right past the picnic grove near the pool
There was no better place to be on a hot summer day than in the spring-fed pool at Dorney.

Swimmers were not the only ones to use the apron around the park swimming pool. On this night in 1960, management of the First National Bank of Allentown invited employees to an "Aloha Party." The nearby water, festive lights and pennants, and a few fake palm trees gave the appearance of a Hawaiian beach for the assembled guests.

Dorney Park hosted the Amateur Athletic Union Junior Swimming Championships for the Allentown Aquatic Club in 1962. Here, winners pose with their trophies.

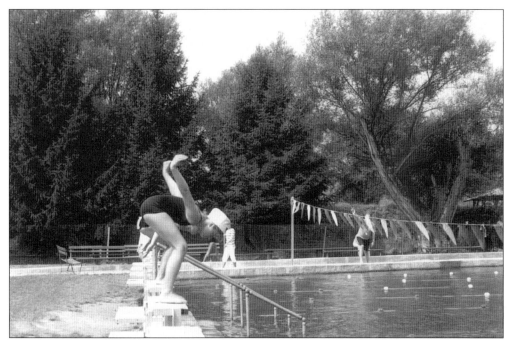

At the starter's gun, the swimmers hit the water during swimming championships at the park pool.

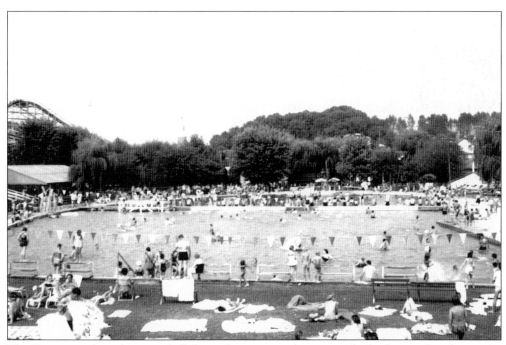

The Dorney pool was huge, and all the park action can be seen in the background in this image. Swimmers surround the old pool. All the fun in the water was in sight of the picnic grove, the roller coaster, and the carillon tower.

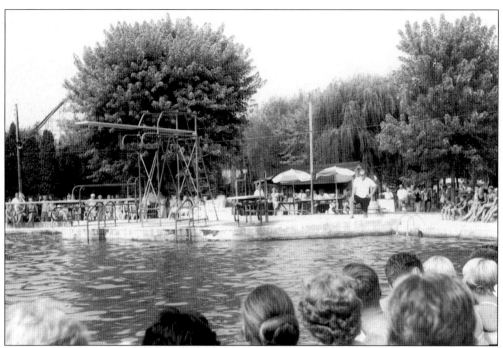

You do not see a "high divey" around public pools anymore. In the 1960s, Dorney Park had the diving boards ready for swimmers or, in this case, competitors.

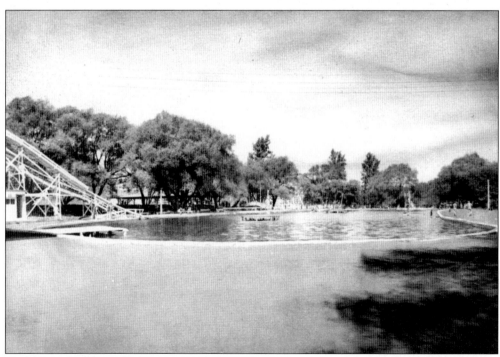

Visible in this view of the Dorney Park pool are the slides, rafts, beach, and cool water. (Courtesy of David Bausch.)

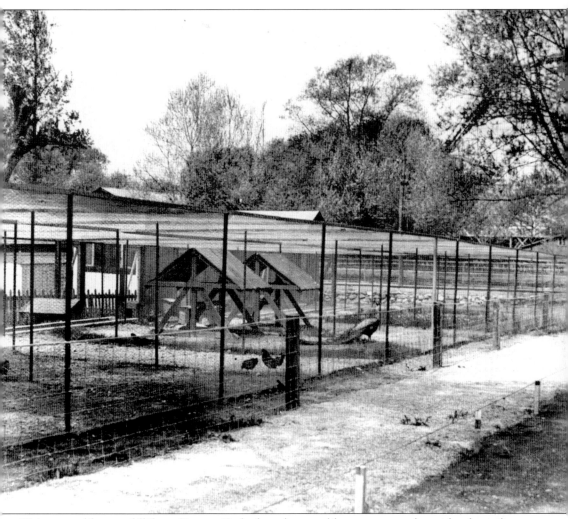

Visitors could see wildlife at Dorney Park that they could not see anywhere else for miles around, especially not in the city. Here are shown the pens featuring a peacock as well as an assortment of other creatures. The roller coaster is in the background. The miniature zoo was highlighted in 1929 literature promoting the park, with this explanation: "The kiddies and adults will enjoy the miniature zoo found at Dorney Park. A stroll through the park will bring you many delights and smiles. The antics of the bear; the racing to and fro of the coyote; rompings of the raccoon; the doings of the squirrels, which with the deer and fox add much pleasure to the day's fun. The beauty of the peacock and pheasants, the graceful swan, wild Mallard ducks, Canadian wild geese, Egyptian wild geese, paddling their way smoothly through the waters of the park." This children's zoo was a clue of things to come at Zoorama.

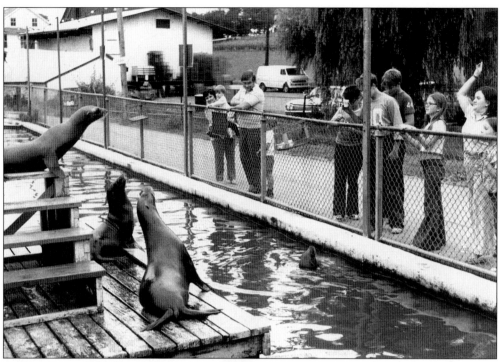

Zoorama and its seal population made good use of the old Dorney Park swimming pool after it was closed to human swimmers. The pool was divided, and the seals had possession of the deep end. The shallow water was reserved for little power boats called Whale Boats. The chimpanzee did not go in for swimming. Nemo was raised at the park and was a popular attraction at the zoo.

Six

TRAINS

The Great Scenic Railway at Dorney Park, sometimes called the Elevated Railroad, was built between 1884 and 1900. It claimed to be one of the first mechanical rides in America. An early park picture shows the ticket booth with a 5¢ ticket price. Another early photograph shows a surrey-type coach on railroad tracks, with "Egypt" labeled across the front and noting that it is one of the first miniature trains in America.

Soon after mechanical rides started appearing around the Dorney property in the early 1900s, the park purchased a small steam locomotive. Today it would be called a "live steam" engine. A track was laid out from the center of the park to the distant reaches behind the swimming pool, almost exactly the route taken by the train in the park of the 21st century. The little train gave the patrons one more thing to do at the park and showed off the property to visitors without making them take a long walk. It provided a little shade, too. Each of the train's three coaches was covered with a fabric top for protection from the weather. The engineer sat on top of the little powerhouse. The steam engine appears in old photographs to be a 4-6-2 configuration, and its "whistles and bells" really were whistles and bells.

For whatever reason, Bob Ott says, in 1934, Bob Plarr turned a willing ear to a young machinist, Miles "Mike" Erbor of nearby Wescosville. Erbor proposed building a brand-new train for the park. It would be modeled after the new rail sensation in the country, the Burlington Zephyr. The real Zephyr set national speed records in 1934 en route to its introduction at the Century of Progress Exposition in Chicago.

Erbor was industrious and creative with his Zephyr Jr. Dorney train project. He used a Model A Ford engine to provide power to electric motors at the train wheels. The motors were hand-me-downs from a defunct newspaper operation in Philadelphia. This gas-electric power train was unique and made for smooth, quiet starts as the train glided into motion.

Most significant about this newcomer to Dorney was its potential to draw riders to the train and visitors to the park. Bob Ott staunchly claims that the new Zephyr ride saved the park during the Great Depression. People reacted to the publicity of a new train ride at the park and showed up in droves to ride it. While amusement parks everywhere were closing down due to the financial pressures of the times, Dorney Park rode the rails of the new Zephyr to prosperity.

One of the earliest additions to the park, right after the arrival of a merry-go-round, was the Great Scenic Railway. It was housed in a large building located where in 1923 the wooden roller coaster would eventually appear. An out-and-back car carried riders at perhaps 10 miles per hour over a series of dips and turns, returning to the starting point. When the new speedy

roller coaster was built, part of the route through the building, to start the first climb, was through the archway opened by the old Scenic Railway of long ago. The Thunderhawk ride of this century still passes through the same tunnel.

For the last 70 years, the Zephyr has passed by picnic grounds, the swimming pool, the boating lake, and the Mill Chute, Skooter, and coaster rides. In this nighttime photograph, taken c. 1970, the Zephyr is passing Journey to the Center of the Earth. It is reflected in the pond that housed the Water Skooters. As it rounded the final turn into the station, patrons would hear the train bell ringing and would spot the crossing lights flashing while the crossing bell clanged. When the Zephyr was introduced at Dorney Park during the Great Depression in America, it drew patrons to the park. This kept the park in business until better times arrived after World War II.

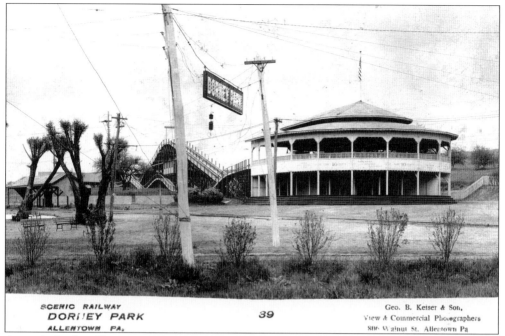

An early "railroad" at Dorney Park was the Scenic Railway. More like a roller coaster than a train, it headed out of the same building where the roller coaster originated.

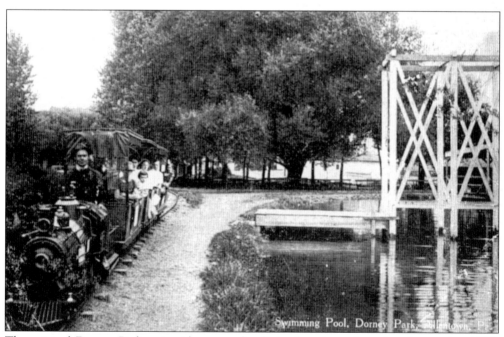

The original Dorney Park train ride passes the diving boards at the swimming pool *c.* 1920. Young Bob Plarr is at the throttle.

Walt Disney said that people love to ride trains and will visit an amusement park to ride one. Long before Disney's parks arrived on the scene with their dominating train rides, Dorney Park featured an early three-car train ride around the park. The route of this old-time live steamer was followed by the Dorney Park Zephyr more than 80 years later. It is likely that when the

Zephyr was introduced, it helped carry the park through the lean days of the Great Depression. The silver Zephyr is shown in the 1960s as it glides past the spinning spaceship ride, the Journey to the Center of the Earth, and the pool of the motorboats.

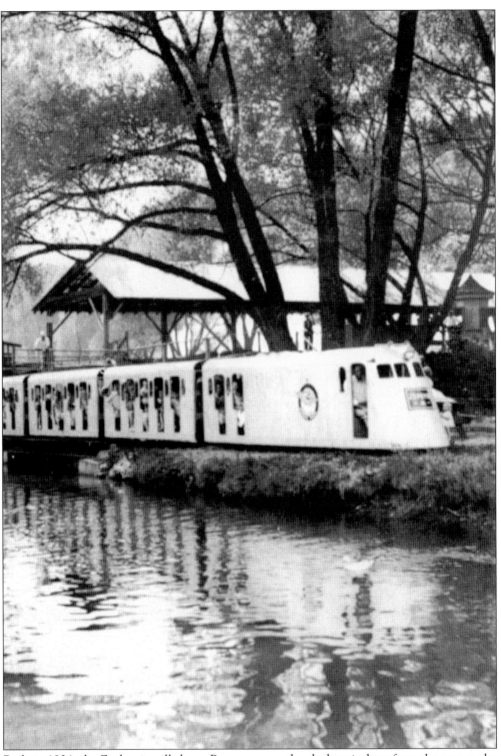

Built in 1934, the Zephyr is still there. Passengers on the sleek train lean from the cars as the ride passes picnic groves along the creek.

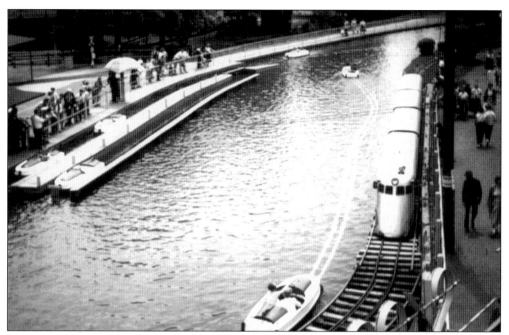

Here is another look at the famous Dorney Park Zephyr on its tour through the park.

The park honored "Choo Choo" Charles Rothlein at a rededication of the Dorney Park Zephyr in July 1973. Rothlein was honored for his "many years of service to the Dorney Park Railroad." The Jersey Central Railroad worker started a new career as a railroad engineer at Dorney Park following his retirement, and he became a fixture at the park. Here Bob Ott points to the plaque attached to the Zephyr engine in honor of Charlie.

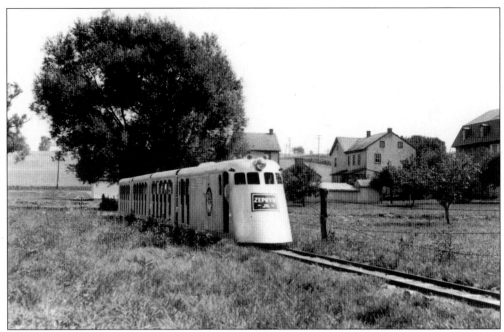

The original Dorney Park Zephyr cruises through a meadow and residential backyards, away from the hustle and bustle of the other park rides, in this *c.* 1936 photograph of the train. The banner "Zephyr Jr." is clearly visible on the front of the train.

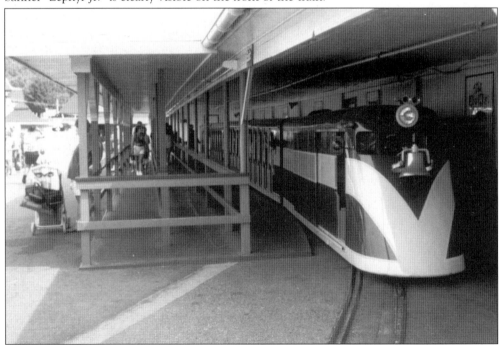

This photograph shows the Zephyr as she looks today, purple not silver, but as sleek and smooth as she was at her introduction almost 70 years ago. Park officials told the author that despite her age, there are no plans to do away with the classy train ride. "We might change the route a little bit, but she's here to stay. It is a relaxing family ride that many patrons look forward to."

Seven

RACETRACK

During the 1930s, an area at the southeastern edge of Dorney Park, along Main Boulevard, evolved from a family baseball park into a Sunday afternoon three-quarter midget racecar track. Various types of races were held there over the years. The track was an oval—almost. Actually, it was lopsided, with the radius of the turn at one end larger than at the other end.

Midget racing made household names of Shorty McAndrews, Doc Shanbrook, Freddie Frame, George Fonder, and Larry Bloomer. Bob Ott describes the midgets as being "very crude" from the start. The early races drew only about 600 fans for each event. Later, when the racers became more sophisticated, the card was expanded to Friday and Saturday night events. Then, when stock car races were the rage, the stocks took over the raceway. These events also featured demolition derbies. Bob Ott remembers that the stock car races, which squeezed 22 cars onto a one-fifth-mile oval, were practically demolition derbies themselves.

"Reds" Crisse, a racing promoter from Florida, and Bob Plarr discussed the idea of using the midget track for racing stock cars. The speedway had remained dormant during World War II, and the interests of race fans had changed. The track had been built for midget racing cars, and a major improvement in the safety fence was needed to run stock cars. The original fence of oak beams and railroad ties was beefed up by running steel cables around the perimeter and then boarding it up to make sure errant vehicles did not get through.

These races were held on Saturday nights, and the park enforced a midnight curfew out of respect for its neighbors. The names that pop out of memories of the stock car days include John Andretti and Fran Hardner. The stock cars packed the stands with race fans. Every Saturday night, 3,000 to 4,000 fans watched the melee. It was a bonanza for the park as fans overflowed the track area and provided extra business for the rides and food stands, as well as generating parking revenue.

The park billed the track as the Dorney Park Speedway, "the oldest Auto Speedway in the Lehigh Valley." Park promotions warned that the novice racing fan would "be surprised to see as many as 25 cars entered in an individual heat on the 1/5 mile macadam track." In the 1950s, the late-model stock car races highlighted a 200-lap feature. Modified sportsman and hobby cars made up the bulk of the racing card, but the midgets returned in 1972. The park bragged that "the return of A.R.D.C. Midgets recalls the past" because the track had originally been designed and built for midget racing. The park periodically booked the Joey Chitwood Thrill Show at the speedway. Chitwood's show was synonymous with thrills and spills.

In the late 1970s and through the 1980s, the thrills came from the Sportsman competition

and Late Model stock cars. Jerry Fried was the race director during this era. Hundreds of drivers cruised the track in preliminary heats; the winners vied for the trophy of the night in the feature.

Noise, dirt, and traffic from the races never endeared the park to its neighbors. The races were a summertime attraction, just when cooling off under the stars would be enjoyed by the neighbors. The friction came to an end when the raceway closed in 1987.

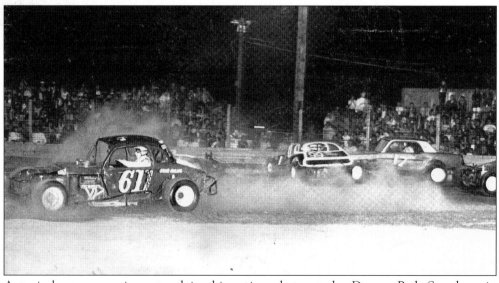

A typical race scene is captured in this action photo at the Dorney Park Speedway in 1975. Drivers Henry Ruth (No. 99) and Jack Heffelfinger (No. 17) have collided while Gary Grim (No. 61) bounds through the infield. (Photograph by Ralph Young, courtesy of Program Dynamics.)

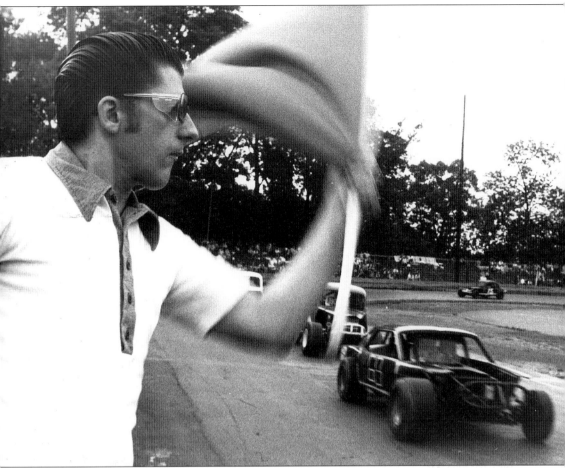

The starter sets the field in motion at the Dorney Park Speedway. Ken Golden is identified as the man with the flag. (Photograph by Burt Swayze for *Call-Chronicle*, courtesy of Bob Ott.)

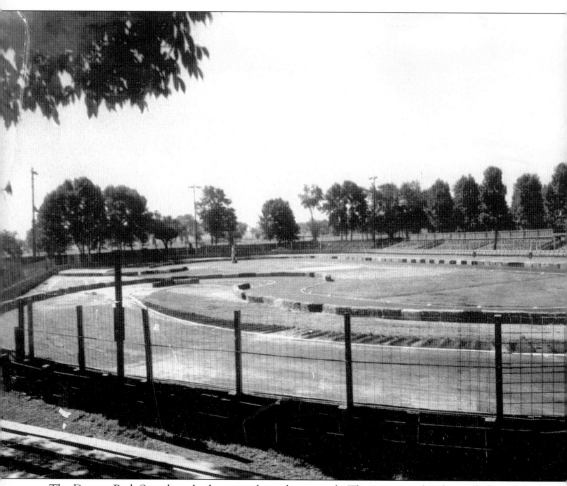

The Dorney Park Speedway had two tracks within a track. The inner circle of straw bales marked the route for the go-carts. In this image, the checkered pylon stands silently waiting for the one-

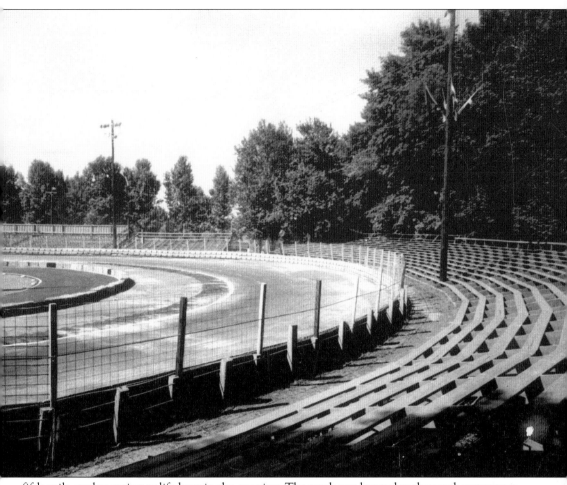

fifth-mile oval to spring to life later in the evening. The track was located at the southeast corner of the property along Main Boulevard. It replaced the old, retired baseball fields.

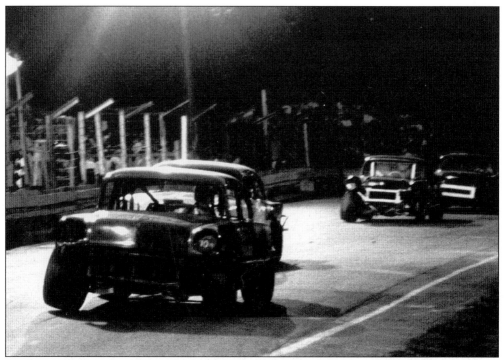

Stock cars raced on Saturday nights at Dorney. The group shown here heads into a turn under the lights.

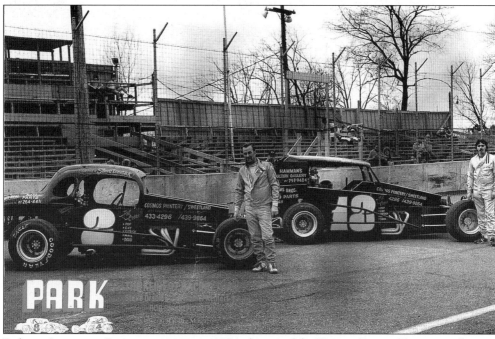

Before a Sportsman Race one evening in 1984, drivers of the Keinert Racing Team proudly pose with their cars. On the left is Steve Drabic, driver of No. 2, and on the right, Homer Keinert, with No. 12. (Photograph by Bob Snyder, courtesy of Program Dynamics.)

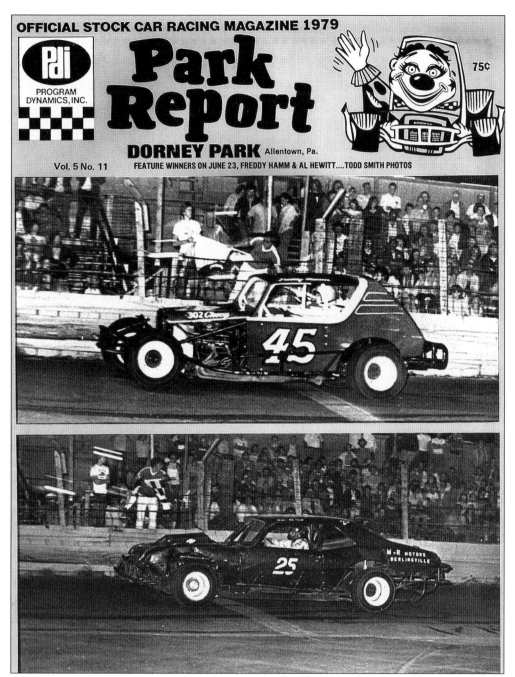

OFFICIAL STOCK CAR RACING MAGAZINE 1979

Park Report

Pdi
PROGRAM
DYNAMICS, INC.

75¢

DORNEY PARK Allentown, Pa.

Vol. 5 No. 11 FEATURE WINNERS ON JUNE 23, FREDDY HAMM & AL HEWITT....TODD SMITH PHOTOS

Two winning feature drivers pass the finish line at the Dorney Park Speedway in the summer of 1979. Freddy Hamm, of Kutztown, is behind the wheel of Sportsman entry No. 45, and Al Hewitt, of Slatington, drives No. 25 in the Late Model competition. (Photographs by Todd Smith, courtesy of Program Dynamics.)

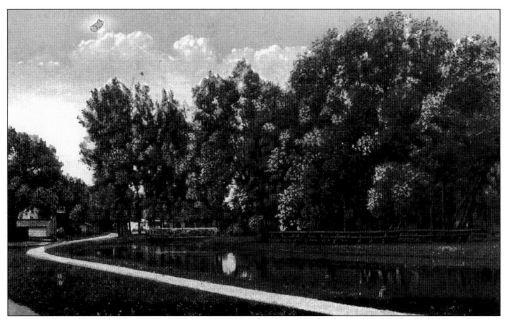

A reference to "lovers" at Dorney Park appeared on this postcard from the early days of the park. This ancient scene is warmly titled "Lovers' Nook, Dorney Park, Allentown, Pa." (Courtesy of David Bausch.)

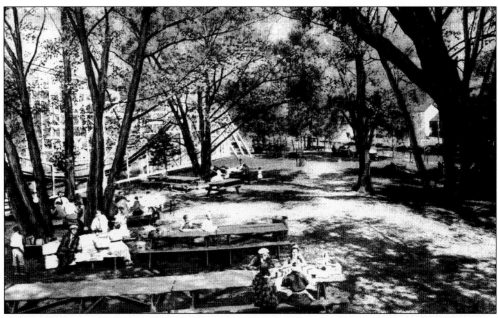

This family is enjoying one of the beautiful picnic groves in the Dorney Park of the 1920s. The cool serenity is interrupted only by the roar of a periodically passing roller coaster.

Eight
EVERYTHING ELSE

Searching through Bob Ott's Dorney Park collection, the author came upon something that stopped him cold. In a 1925 booklet promoting the features of the park was a mission statement. This modern business tool had certainly not yet appeared on the scene for most businesses in 1925, but then Bob Plarr and Dorney Park were not "most businesses."

IT IS THE MISSION OF DORNEY PARK TO HELP YOU keep young—young in mind, in spirit and in body. And when you must grow old—(but, then, why talk about it? Nobody must grow old)—the added mission of Dorney Park is to help you grow old gracefully.

Again, with words first published by the park management more than 75 years ago, we learn about a new Dorney Park:

When next you come to Dorney Park you will be delighted with the new park. New in every sense of the word. For, while no miracles have been wrought, you will not recognize in the Dorney Park of 1925 the old park.

Last year Dorney Park began a new life. Fifty-three picnics were held there during what we recall was a short summer season. But during that time a new roller coaster was built; new Scooter Cars were put into play, and new Boats added to the Lake, for the enjoyment of visitors and picnickers. This was but the beginning. The new Coaster met with wonderful approval. And encouraged with the success of the summer of 1924, The Dorney Park Coaster Company is ready for the 1925 Season with more attractions for your enjoyment.

Not too many readers will remember the first big building on the Dorney Park skyline. The Casino was different from what casino-goers are used to today. There were no slot machines and no blackjack, but the Casino featured a "cave of the winds," pool tables, bowling alleys, and a soda fountain. In 1934, the Casino met its demise when a heavy snowfall caved in the roof.

Three disastrous fires in the park changed the landscape during Bob Ott's tenure. An electrical fire in the Whacky Shack in 1973 ruined the old dance-hall-turned-skating-rink-turned-storage-barn. The Chanticleer, an old carousel with an amazing history, was destroyed while in storage. On September 23, 1983, just a few months before the start of the park's 100th-anniversary celebration, a major eruption burned down the merry-go-round, the Bucket-of-Blood, the Iceberg ride, the Sea Dragon, an ice-cream stand, the Ski Ball game, and the stand

in which the fire started, the Mexican Border Stand. The destroyed merry-go-round was Le Grand Carrousel, built in 1915. The first of the fires roared through the old swimming pool bathhouse on August 14, 1964, which by this time housed Zoorama.

For several years during the 1950s and 1960s, the park was home to Melody Circle, a theater-in-the-round tent. Famous performers made appearances in the shows, called the Allentown Summer Theater. In 1969, these big names were scheduled: Ruta Lee, Denise Darcel, Vivian Blaine, and Morey Amsterdam. Professional stage performances appeared in the park early on. Bob Ott has a copy of an opera advertisement from 1901. The Robeson Opera Company was staging *The Mikado*. In the same advertisement, the Allentown Band program was featured. Headed by musical director Martin Klingler, the band played for more than two hours.

From here on in this book, the author shares with readers many of the old pictures in Bob Ott's collection. In many cases, they do not always fit under a specific heading, such as "racetrack," or "merry-go-rounds." They are, however, of interest to Dorney Park fans and belong in this book somewhere.

Many of the images in the book contain recognizable faces, but there is no record of who the people are. If you spot yourself or someone you know on these pages, please drop the author a note at the e-mail address reserved for this purpose, DorneyBook@aol.com, with your information or any other comments about anything you read here. Now back to the pictures.

We all called it the Penny Arcade, but in 1948, the name above the entrance was "Dorney Park Arcade." Once a stately hotel and restaurant, the park replaced the hotel with amusements. Penny games filled the space, and a bank of Skeeball machines were added to the porch. The farmhouse along Dorney Park Road became the Dorney Park Hotel, and the hotel rooms and dining room operation ended up there.

Long before video games, guys found more simple amusements at the Dorney Park Penny Arcade in 1946. For a handful of small change, you could view the "Battling Twins" or catch the "Hot Tango." One wonders just what these kids saw if they dialed up "Miss Broadway" or "Cherry Blossom Time."

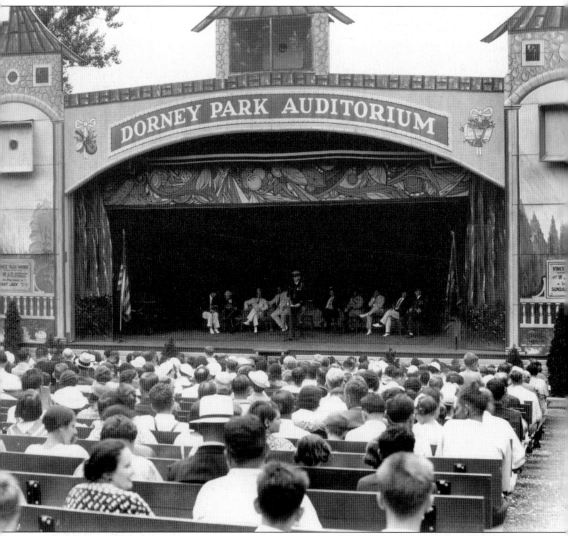

A young man addresses this *c.* 1930 crowd at the outdoor Dorney Park Auditorium. A print ad for the park from the era proclaims, "INNOCENT AMUSEMENTS in endless variety, making it the only resort peculiarly adapted by nature in this section for Sunday Schools, Excursions, Churches, Secret Societies, Private Parties, &c." Judging by the signs on either side of the stage, an appearance by Vince Blue Mondi, who broadcasts on WJZ afternoon and evening "in person" as a one-man band, exemplified an innocent amusement. The theater was in constant use, as the park provided entertainment for the patrons. Free movies were shown throughout the Great Depression.

It was not all speed and mechanical rides. This 1930 picture of Dorney Park shows the old baseball field. The players were pretty young, but the size of the crowd proved there was interest in the event. Half the bleachers were under the shade tree. The ball games eventually gave way to the new raceway.

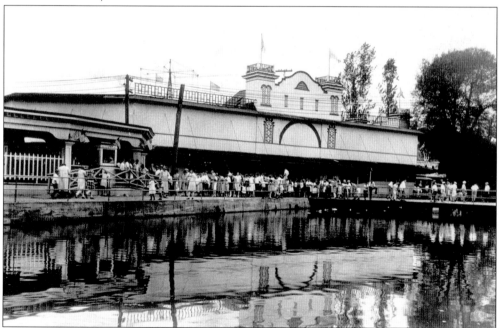

This handsome facade was upgraded many times after this picture was taken in 1927. The Scenic Railway departed from the big building, and the Mill Chute entrance is shown on the left. The parachute ride is visible in the distance.

Melody Circle was the theater in the round that brought Broadway to Dorney Park. It was a constant struggle (as it was for many small theaters) to keep the doors open, but the project continued to try for "one more year" through the late 1950s into the 1960s. This photograph

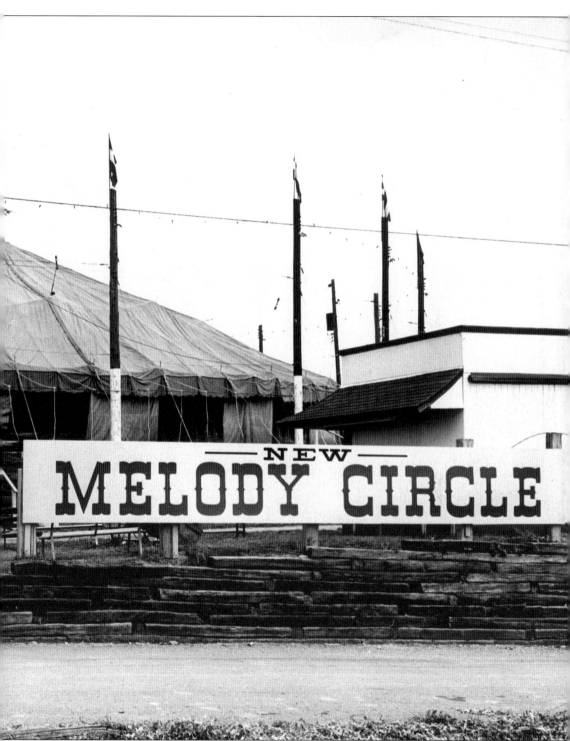

from 1955 is a reminder of how large and dominant the tent actually was. (Photograph by Sam Smith, courtesy of Bob Ott.)

When Steel Force came on the scene in 1997, it almost dwarfed its little sister, the roller coaster, now named Thunderhawk. Both thrill rides appear in this picture.

This 1927 picture shows the old Mill Chute and its entrance. The ride started innocently enough with a slow float through darkened tunnels. It ended with a splash at the bottom of the chute on the left into a large pond of water. For some reason, the ride was popularly known as the "Tunnel of Love." The roller coaster looms in the background.

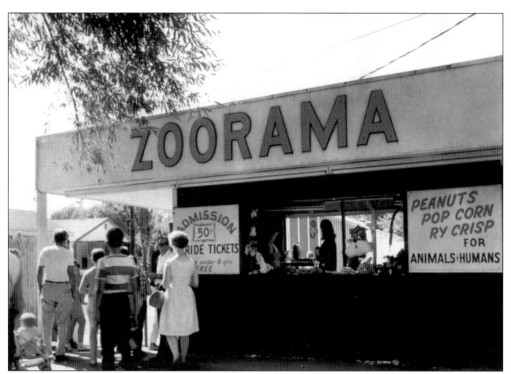

Zoorama carried on the tradition of having a place for park patrons to interact with animals. For 50¢, you could come in contact with everything from a turtle to an elephant.

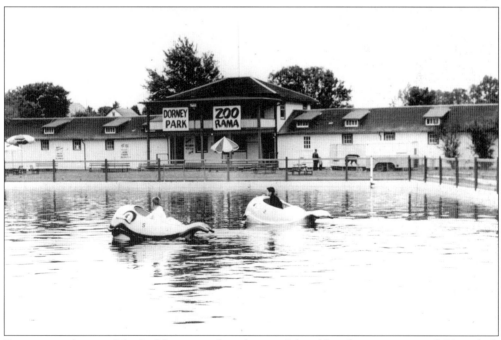

Zoorama made use of the bathhouses and pool area of the old park swimming pool. Here, kids play on the Whale Boats where Olympic swimmers once practiced.

Between camera set-ups for the movie *Where Angels Go, Trouble Follows*, actress Rosalind Russell rides the Chanticleer with guests from St. Mary's Academy.

The main Dorney Park midway was a busy place on this afternoon in 1946. The big building is the merry-go-round. The white building behind the trees is the ice-cream and waffles stand. The sign on the pole to the left announces the appearance of Rev. Clarence Rahn. (Photograph by Guiley Finch, courtesy of Bob Ott.)

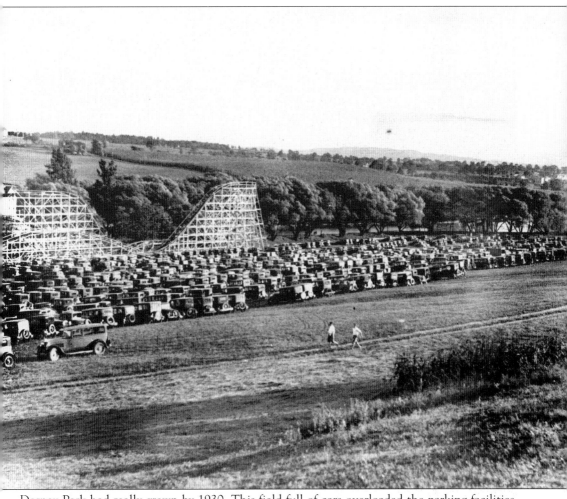

Dorney Park had really grown by 1930. This field full of cars overloaded the parking facilities and spread for blocks in each direction. Bob Ott explains that the two cars in the foreground that are not aligned with the others were located near the top of the hillside parking area where traction was poor. Facing as shown, they could expect to get out of the park safely. Had they faced the same direction as the lower rows, the drivers risked getting stuck in soft ground. Note that there are no houses to be seen on the distant hillside, only a barn in the distance. That area is now fully populated. In this picture, it looks as if a modern-day antique car show is taking place.

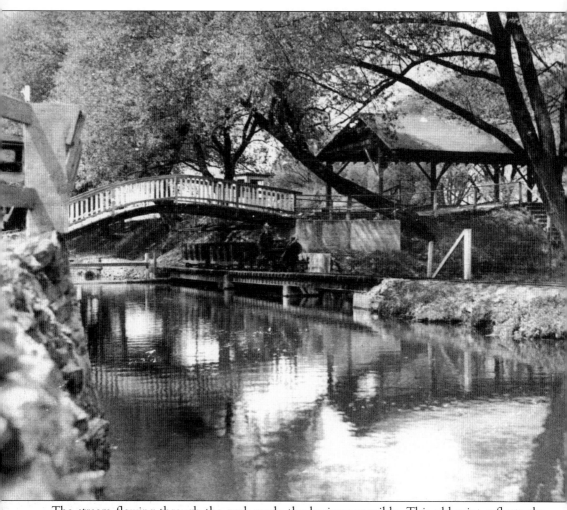

The stream flowing through the park made the business possible. This old print reflects the serenity folks of a century ago found at Dorney Park. The little arched bridge is still there. The train tracks along the right bank are still in use, too, by the Zephyr.

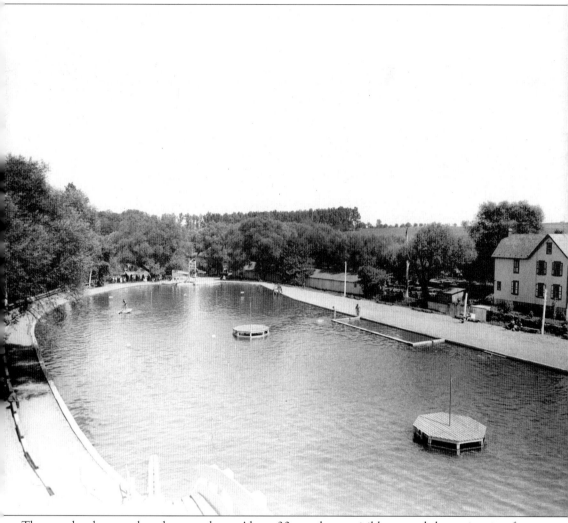

They are hard to see, but they are there. About 30 people are visible around the perimeter of the park swimming pool. Some are in the water (on a raft and on the steps). Others are on the sand under the shade of trees, not ready yet to make the move into the water. The year is 1929, and the original pool is still a really big deal at Dorney.

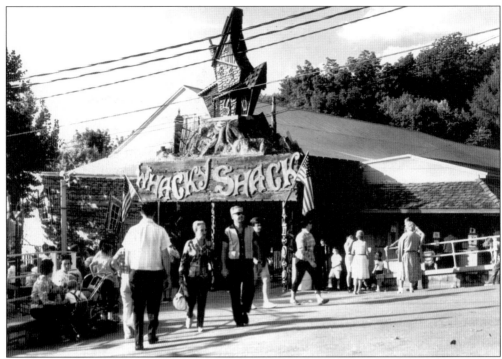

It was fun. It was a fun house. It was whacky. It was the Whacky Shack. This old building started out as a dance pavilion. It became a skating rink and was later the Whacky Shack. It was finally used as a storage building. Its time serving Dorney Park came to an end when it was destroyed in a fire. It is seen here as it looked in 1968.

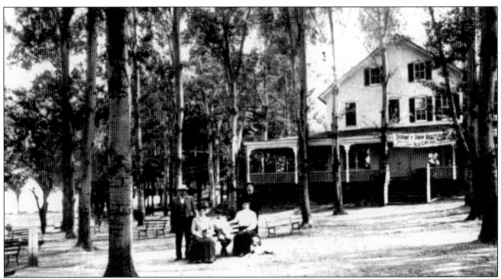

This 1906 postcard shows Jacob Plarr and his family in front of the Mansion. Little Bob Plarr, who would eventually own and manage the park, is seated on the bench next to his mother. The Mansion banner promotes "quick lunch" and ice cream. The Mansion is now the arcade.

This little photograph folder and its contents tell a lot about the times. Having your photograph taken was a unique treat. The concept of an amusement park photograph was so important that the house photographer J.F. Fasnacht had custom folders made and even lived with his family on the park grounds during the season. Park visitors took home pictures like this in 1907 and 1908 as souvenirs of their day at Dorney Park.

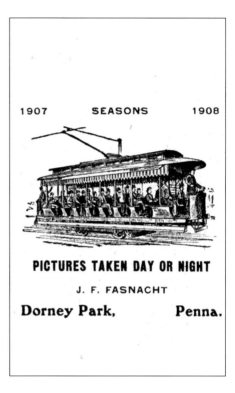

1907 SEASONS 1908

PICTURES TAKEN DAY OR NIGHT

J. F. FASNACHT

Dorney Park, Penna.

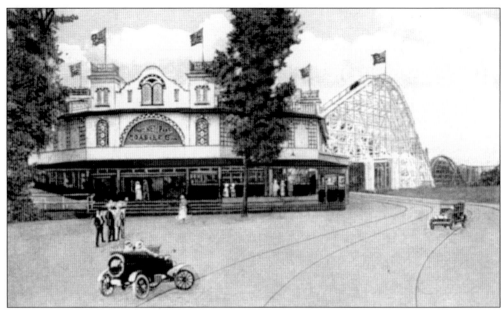

The old cars near the park entrance, shown here in the mid-1920s, cross the trolley tracks, which the park depended upon for patrons during the early years. The new coaster is visible, in its original configuration of out-and-back, before the redesign to the present route was accomplished.

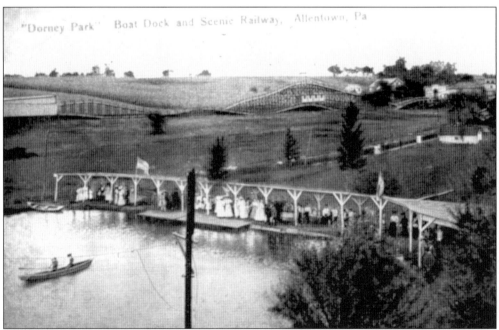

Two of the early Dorney Park amusements appear together in this picture from 1909. In the foreground is the boating lake, with throngs of would-be boaters waiting on the dock. In the background, the early thrill ride the Scenic Railway can be seen. At 10 miles an hour, it was quite a trip. The small white building on the right was the local schoolhouse. Sally Plarr Ott attended classes there.

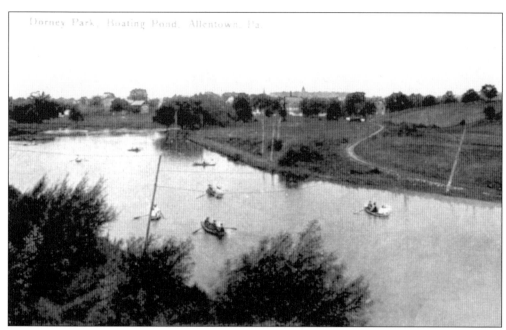

Once you rowed out onto the Dorney Park boating lake, there was plenty of room away from the crowds.

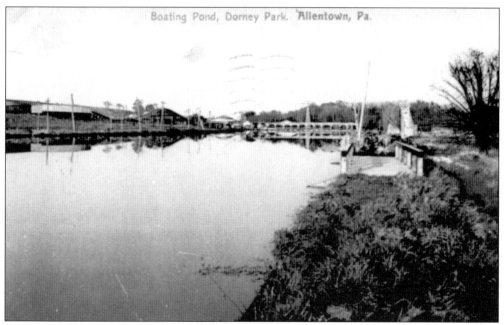

This 1907 picture, taken from way out on the boating lake, helps the viewer appreciate the expanse of the Dorney Park site. The boating lake entrance, the original Venetian Swing ride in the background, the Casino, and the Scenic Railway ride are visible. (Courtesy of Bob Otr.)

Park buildings were becoming visible in the early 1900s. These four adventurers chanced a walk across a dam in Cedar Creek, far away from the action.

When the Chanticleer came to Dorney Park from Coney Island, its construction was an attraction in itself. Using a large crane, workers matched the roof to the supporting structure. (Photograph by Milton Rockmaker for *Call-Chronicle*, courtesy of Bob Ott.)

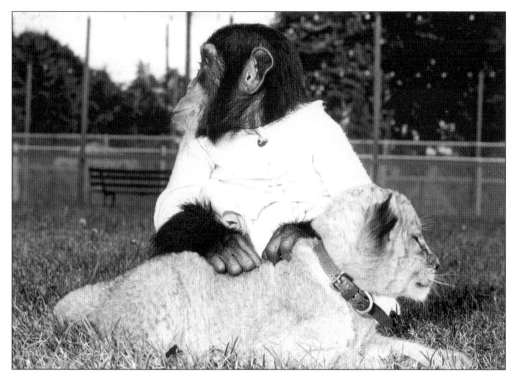

Zoorama animals enjoy each other's company in this 1963 Dorney Park photograph.

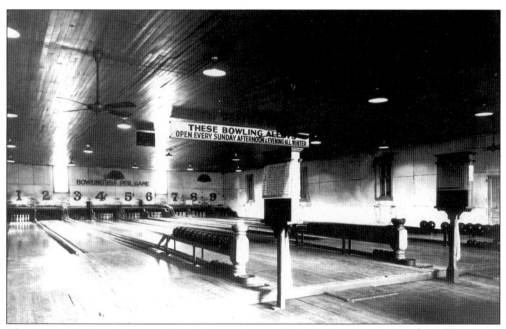

The Dorney Park Casino provided an innovation to the Lehigh Valley—a bowling alley. Many are surprised to learn of the lanes provided by the park. Pool tables were also available in the Casino. Bowling was an expensive 15¢ a game, and the lanes were open Sunday afternoon all year round.

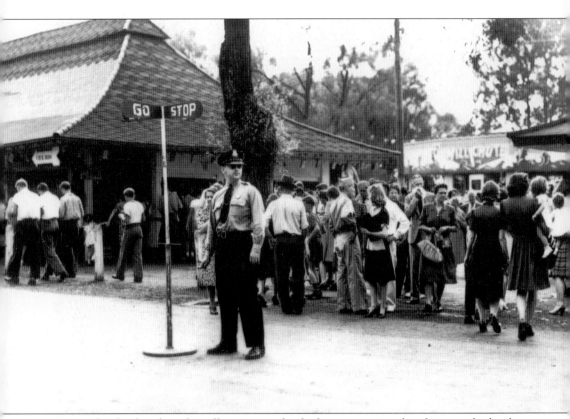

As much a landmark as the roller coaster, this little crossing signal and its standard policeman in charge of the operation were missed by park patrons when the township finally agreed to close Dorney Park Road to traffic through the park. The park had been bisected by the road from the beginning, and throngs of park patrons crossing the road depended upon this little sign to halt traffic. They could have built a bridge or installed a classy traffic signal, but the manual stop-go signal stayed there until there was no more traffic. Bob Ott had a personal concern about the safety issues at this intersection, and he lobbied for years to close the road.

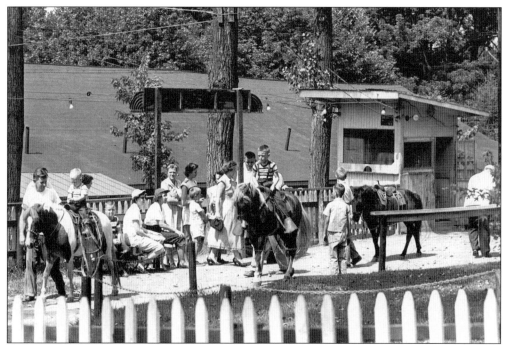

Not all the rides went fast. Some were attractive because they went slowly, such as this pony ride. Located up the hill from the skating rink, these ponies provided a real treat for the animal lovers at the park.

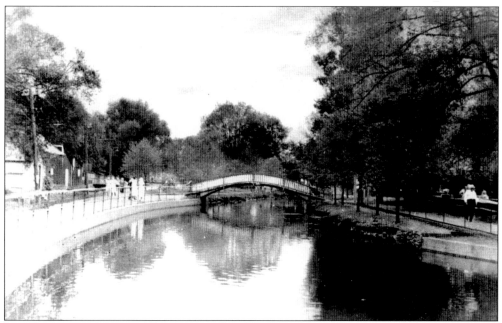

The reflections of the trees and the bridge in the stream testify to why folks loved to come to Dorney Park. It was comforting, and it was quiet. Notice the set of train tracks that passes the picnic tables on the right. A hundred years later, the bridge is still there, and the train tracks are, too.

It was the streams and trout ponds that made it all possible. Solomon Dorney's fish weirs enabled him to provide fresh fish dinners at his picnic site. In 1907, the stream and the road were there, but the bridge (below) was not prepared for heavy traffic. One of the buildings, along the road from the old farm property, can be seen on the left.

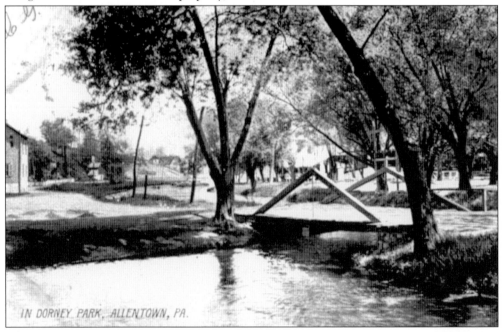

IN DORNEY PARK, ALLENTOWN, PA.

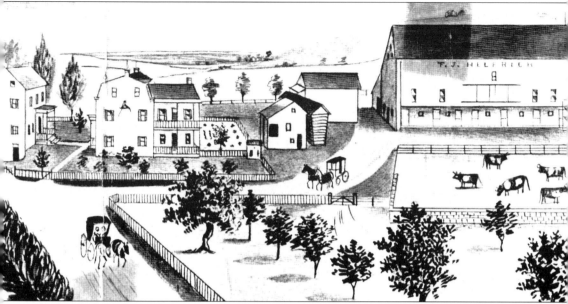

An unknown artist took up pen and ink *c.* 1875 and sketched this property, which later became part of Dorney Park. The drawing shows the dairy farm and residence of T.J. Helfrich in South Whitehall Township, Lehigh County. Getting oriented to this scene is somewhat of a task. The road that passes the scene on the left later became Dorney Park Road. The building on the left was probably occupied by workers on the farm property. The second building from the left is the farmhouse. This later became a hotel, possibly as early as 1880, and was then the Dorney Park Hotel. Both of these buildings appear in some of the oldest photographs of the park.

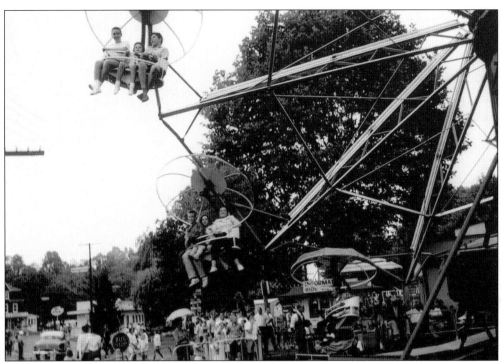

Rides in space provided thrills for those of us who were basically earthbound. Dorney Park was more than willing to get you off the ground on these two spinners. The parachute ride lifted you up and dropped you down, but nothing like the Dominator would do decades later. The silver rocket ships cruised slowly and quietly, up and out and around and around. It was a trip such as you might experience on the way to the moon. (Courtesy of David Bausch.)

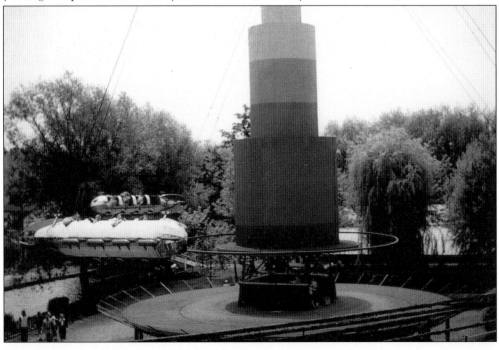

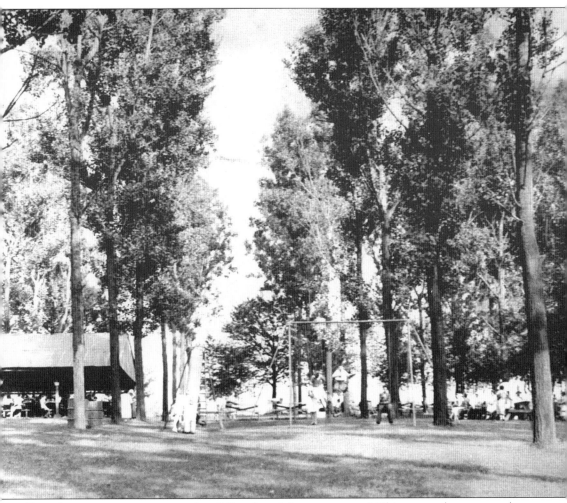

How about swings, seesaws, and a sliding board for amusement? This scene shows an early picnic pavilion, with adjacent activities among the shelter of the tall trees. When the park created promotional literature in 1929, the kiddies' playground description read, "The children have not been overlooked at Dorney Park. There are swings, see-saws, slides, wheel-over and sand pits for the free enjoyment of the youngsters. The Dorney Park Children's Playground is most complete in every way. Children like to romp and play here." The popularity of this playground is evidenced by this picture.

The author has counted 32 picnic tables in this picture of a shady grove in the park in 1925. The tables are not yet filled, but they will be. Bob Ott says this was the "orange grove." Each picnic area was painted a different color. Picnickers could look for the silver, green, or orange grove to set up for the day. The old dance pavilion is in the background.

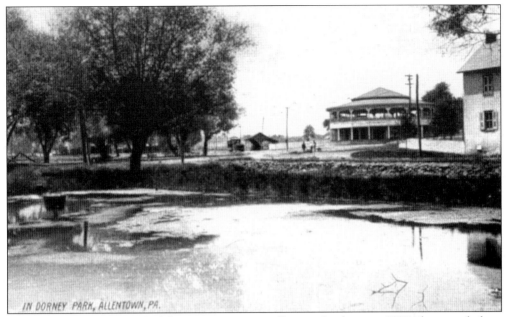

IN DORNEY PARK, ALLENTOWN, PA.

To you, this is a picture of a lake. To me, it is a trolley car. In this rare 1907 photograph from the early park days, one can spot the trolley passenger shed along with the little trolley waiting there. A group of passengers awaits along the road. The white house of the original Helfrich farm is visible on the right.

No one knows who they are or where these ladies are standing. It may or may not be at Dorney Park. The board features advertisements for tobacco, food, scrap, a theater, and Dorney Park. Two posters announce the coming Swabian Festival, held each year at the park.

During World War II, *c.* 1942, the annual ox roast and Pennsylvania Dutch apple butter party featured a patriotic theme. A vegetable flag, made up of fresh vegetables, caught the attention of all.

Soon after the turn of the century, *c.* 1908, immigrants from Germany presented the Swabian Fest at the park. It was held under the auspices of the Lehigh Saengerbund of Allentown. A parade of pheasants in costumes was headed by the Allentown Band, and "Real True Genuine Imported Saur Kraut" was served. Most notable at the festival were the "vegetable flag" and the "fruit column." These were very temporary displays, since they were made up of real vegetables and fruits. Tomatoes, melons, cabbages, apples, oranges, and bananas filled in the decorations. They were erected overnight before the festival and removed immediately afterward.

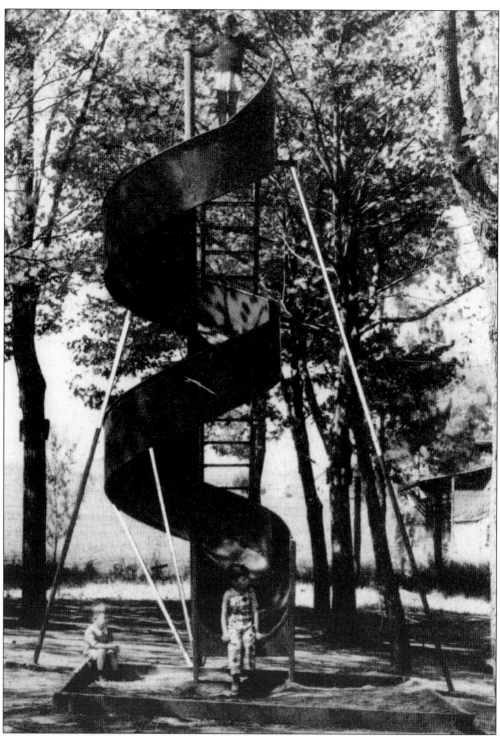

As a kid, the author thought this "slidey" was the greatest. It was part of the free entertainment for the little ones. It survived a long time, finally succumbing to liability concerns for the safety of the children.

"Dorney at night" is the title of this 1907 postcard. The picture shows eight couples sitting on park benches along a wooded path. One couple is either arriving or leaving. Perhaps this is more evidence that romance blooms at Dorney Park. The card identifies the location as Dorney Park, even though the location of the path eludes us. (Courtesy of David Bausch.)

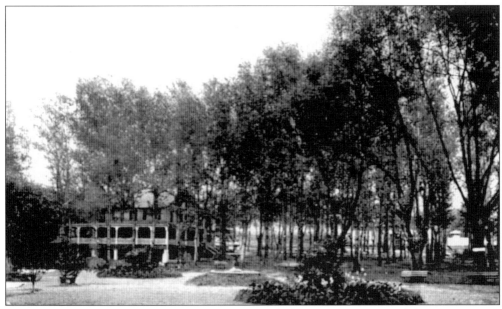

Perhaps that elusive path in the picture above could be somewhere around this Dorney Park picnic grove. We do know where this is. The Mansion is the giveaway. We know when it was, too. The card is postmarked with an October 1913 date.

This decal appeared on the skate cases of roller-skaters who frequented the Dorney Park Roller Skating Rink 50 years ago. Maybe it was used as a bumper sticker, too. Either way, it is vintage Dorney Park. (Courtesy of Wally Ely.)

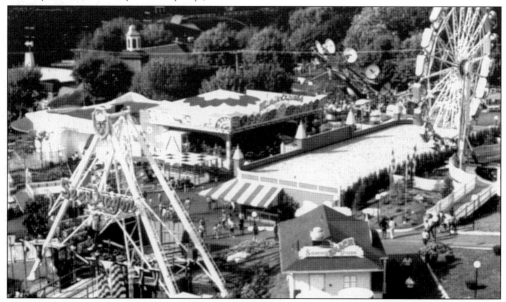

Shown here is the scene on the midway in the 1980s. The fearsome Sea Dragon is in the foreground, with other rides and buildings visible, including the Music Express.

An artist welcomes a signature line to identify his work. How about a three-foot panel hanging with your work on the carousel, ridden by thousands of people every day? That is what Albert Rue Bailley of Lansdale got, as recognition of his merry-go-round paintings on the 1916 Philadelphia Toboggan carousel at Dorney. This photograph was taken in 1982. (Photograph by Brenda Kalb, courtesy of Bob Ott.)

It could not have a better name. Le Grande it was, and it announced it to the world above the main entrance, as shown in this 1982 view. (Photograph by Brenda Kalb, courtesy of Bob Ott.)

We always think of horses (or in Dorney Park's case, roosters) to ride upon when spinning along on the merry-go-round, but this picture of one of the chariots reminds us that we can ride in style without mounting a steed for the ride. (Photograph by Brenda Kalb, courtesy of Bob Ott.)

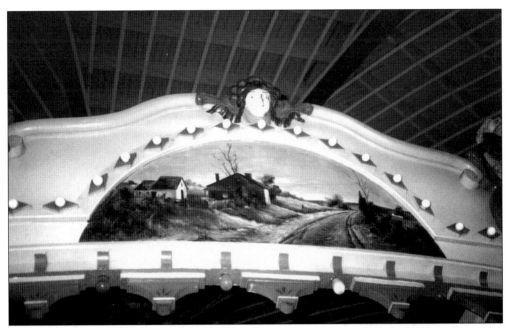

Riding the carousel? Look up. The paintings that adorn most carousels are outstanding. This pastoral scene is depicted here in 1982, as it appeared on Le Grande Carrousel at Dorney Park. (Photograph by Brenda Kalb, courtesy of Bob Ott.)

The music was loud and beautiful. That is because the carousels have their own Wurlitzer organ grinding out music, show tunes, marches, and patriotic melodies. It seems as if you never hear the same one twice. The organ is pictured here in 1982. (Photograph by Brenda Kalb, courtesy of Bob Ott.)

A familiar sight around Dorney Park was Bob Ott checking out the place, riding in his Alfundo golf cart. The front of the golf cart is painted with lettering that reads, "the Fun Place." On the side, it reads, "the Natural Spot."

There is no modern-day evidence who these performers were, but their purpose was clear. Seen here on Memorial Day in 1947, they were honoring American veterans from all the previous wars. The site of this memorial was between the old park entrance on the left and the Dorney Park Inn on the right.

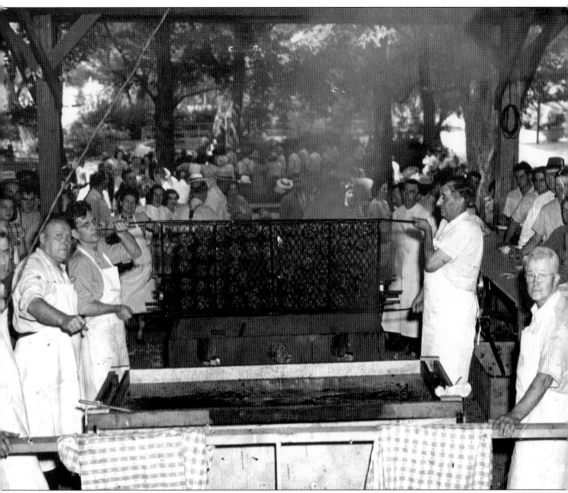

It took an army to cook these hamburgers for a catered private picnic one afternoon in 1949. We even know who some of the chefs are. From left to right are Howard Knecht, Bob Plarr, Bob Ott, and Sally Ott. On the right are Henry Frey, Bob Nonnemaker, and Charlie (last name unknown). This grill, built at the park, had a concrete pit that was filled with sand and topped with charcoal. The hamburgers were not just "hamburgers" but were chopped beef. The operators loaded the pair of grill sections with burgers and closed the grills around them. After cooking, the finished burgers were dumped into the stainless-steel tray in the foreground and served to the guests. Meanwhile, another grilling was started. Each batch held about 50 burgers.

The two Bob Otts check out the anniversary birthday cake in 1984 and beam from the top of the roller coaster. The park, particularly the Flying Dutchman, is visible in the background.

The closing of the road through the park meant a lot to Bob Ott. His concerns for the safety of park patrons led to years of frustration as he lobbied officials to close the road. Shown here with coffee mug in hand, Ott has hauled out a park bench into the middle of the formerly busy road and pauses to admire his handiwork. The road closing had extensive fringe benefits because the property could now be fenced in and an admission charge instituted. Park patrons could now roam the property safely, without danger from passing traffic.

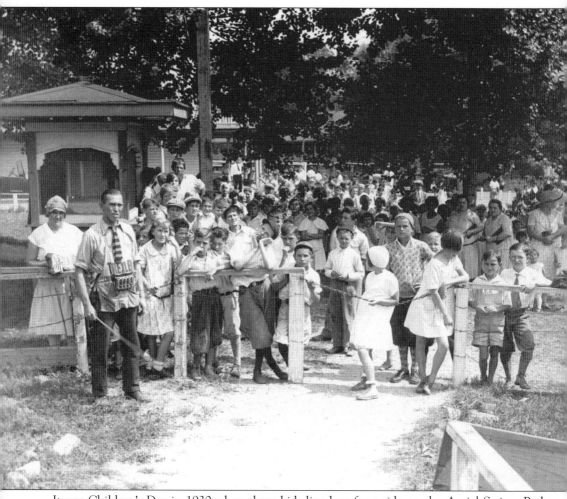

It was Children's Day in 1930 when these kids lined up for a ride on the Aerial Swing. Park employee Bob Shellhammer Sr. was the operator, watching the gate and collecting tickets.

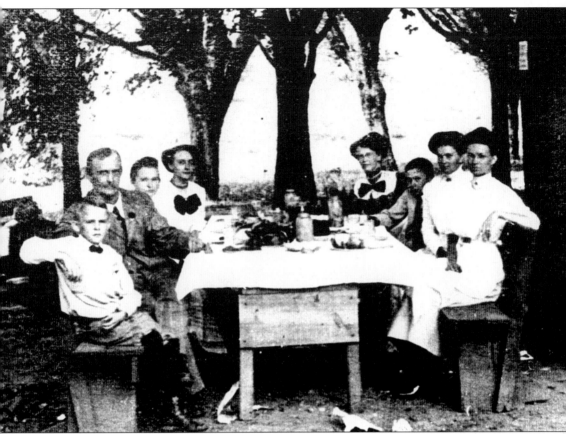

A family poses in 1900 for a photograph of their outing at Dorney Park. The picnic facilities were just right for a day away from the city. They were dressed pretty formally for a day in the park, but that is what the styles of the day dictated.

Rides come and go over the years. In 1960, the kiddies enjoyed a tour in little two-seater cars. The ride was called the Panther. It had an elevated section, as seen here on the right.

One ride with substantial durability over the years has been the Tilt-A-Whirl. In this 1952 photograph, the spinning has stopped for a moment for a new supply of riders to get on board.

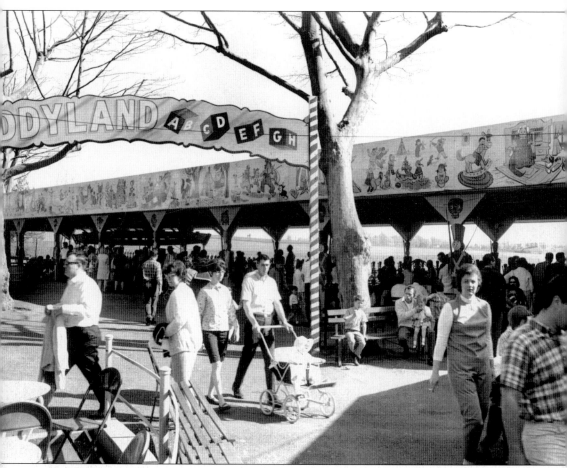

Kiddyland was a popular stop for families. Child-size rides of every sort provided amusements for the youngsters who did not qualify for the adult rides. (Photograph by Sam Smith, courtesy of Bob Ott.)

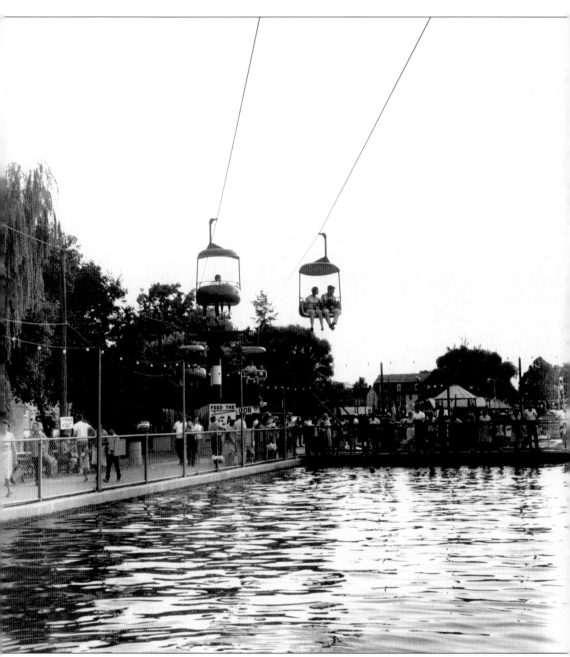

The Skyride gave patrons a view from above as their airborne carriages crossed the swimming pool, the Water Skooter, and the Zephyr train tracks.

Labor Day was one of the most popular events of the year at Dorney Park. Here we see the banks of copper kettles heating over a wood fire, in which apple butter was made. There was also a 1,200-pound ox roast, and shoo-fly pie was available while it lasted. The brochure below reminds us that the events of the day were spoken "in the dialect," meaning Pennsylvania Dutch. The Pennsylvania Dutch apple butter party was an outgrowth of the old Schwabian festivals from the beginning of the 20th century.

THE ORIGINAL

Pennsylvania Dutch Apple Butter Party

(IN THE DIALECT)

DORNEY PARK
The Natural Spot
ALLENTOWN, PENNSYLVANIA

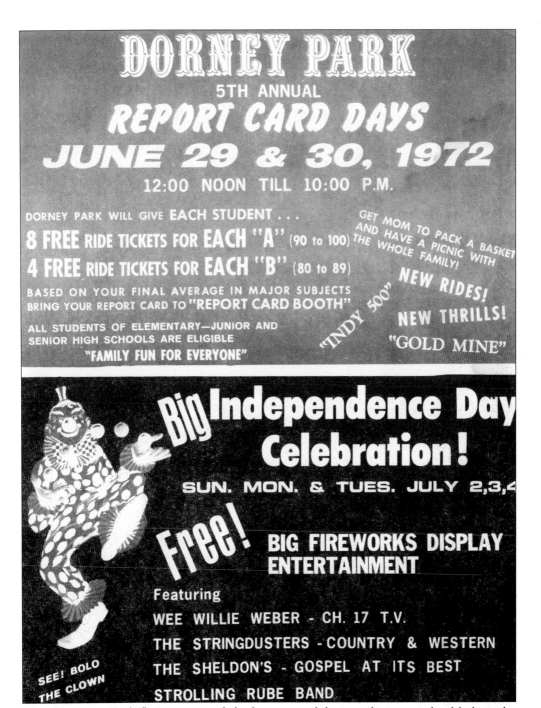

DORNEY PARK

5TH ANNUAL
REPORT CARD DAYS
JUNE 29 & 30, 1972
12:00 NOON TILL 10:00 P.M.

DORNEY PARK WILL GIVE **EACH STUDENT . . .**

8 FREE RIDE TICKETS FOR **EACH "A"** (90 to 100)

4 FREE RIDE TICKETS FOR **EACH "B"** (80 to 89)

BASED ON YOUR FINAL AVERAGE IN MAJOR SUBJECTS
BRING YOUR REPORT CARD TO "REPORT CARD BOOTH"

ALL STUDENTS OF ELEMENTARY—JUNIOR AND
SENIOR HIGH SCHOOLS ARE ELIGIBLE

"FAMILY FUN FOR EVERYONE"

GET MOM TO PACK A BASKET AND HAVE A PICNIC WITH THE WHOLE FAMILY!

NEW RIDES!

NEW THRILLS!

"INDY 500"

"GOLD MINE"

Big Independence Day Celebration!
SUN. MON. & TUES. JULY 2, 3, 4

Free!
BIG FIREWORKS DISPLAY
ENTERTAINMENT

Featuring

WEE WILLIE WEBER - CH. 17 T.V.

THE STRINGDUSTERS - COUNTRY & WESTERN

THE SHELDON'S - GOSPEL AT ITS BEST

STROLLING RUBE BAND

SEE! BOLO THE CLOWN

The old Dorney Park flyer announced the big event of the year for many school kids in the Lehigh Valley. By taking your passing report card to the park, it could be converted to ride tickets. It made working for good grades really worthwhile. The free entertainment on the Fourth of July made it a good idea to plan another trip back to the park a few days later.

Out with the old, and in with the new. The old hotel in the above picture shows how it appeared in the late 1990s, before it was torn down in 2002. Meanwhile, the new entrance to the park greets visitors and starts them on their thrilling adventures at Dorney Park and Wildwater Kingdom. What will the history books 100 years from now have to say about the changes in the park?